MVFOL

petesouza ✔
The Obama White House

Donald J. Trump ✔
@realDonaldTrump

An 'extremely credible source' has called my office and told me that @BarackObama's birth certificate is a fraud.

August 6, 2012 3:23 PM

SHADE

A TALE OF TWO PRESIDENTS

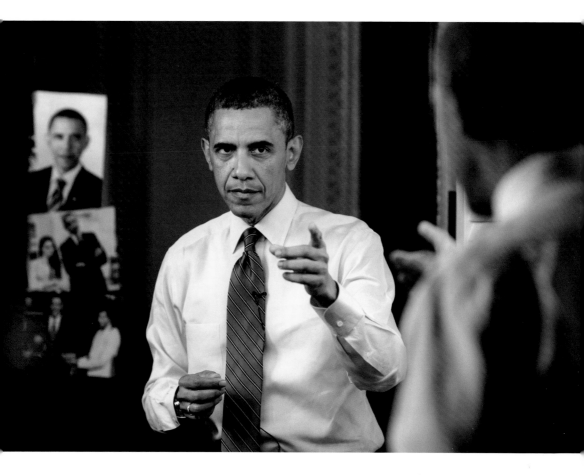

PETE SOUZA

LB

LITTLE, BROWN AND COMPANY
New York Boston London

petesouza ✔ Live TV in the Scandal Room at the Watergate Hotel.

Why I Throw Shade

Inauguration Day 2017 was an emotional day. I had spent eight years visually documenting President Barack Obama's time in office as his Chief Official White House Photographer, and I was exhausted. I looked forward to a break from my demanding schedule but knew I'd miss interacting with him and my White House family. We had all grown close and would suddenly be separated that day at noon.

What made the day surreal was the person President Obama was handing the keys over to. It wasn't his former Secretary of State Hillary Clinton, as we all had thought. It was a carnival barker who had ascended to the presidency by sheer bravado, bullshit, and outright lies. We now know the Russians had affected the election also and changed the course of history. Whether his campaign was directly involved is still being investigated as I write this in the summer of 2018. Regardless, I was convinced that the incoming president was not at all up to the task.

Following the inauguration, as our helicopter lifted off from the U.S. Capitol, one of my White House family members asked me how I was doing.

"I'm depressed," I said. "I watched this guy"—pointing to President Obama, seated across from me—"every week in the Situation Room, asking thoughtful questions, listening to advice, making tough but well-informed decisions on really important issues. But this other guy," I said, glancing out the window to where the new president had watched us depart, "is not capable of that."

I had seen what the presidency required—not just in the Obama administration but years before, when I was an official photographer for President Reagan. And both Presidents Reagan and Obama took the job seriously and respected the office of the presidency. That didn't appear to be true for the new guy.

At the time, I hoped he would surround himself with competent people, learn on the job, and not lead us down a dangerous path. Unfortunately, he's become much worse than any of us feared. The White House now emanates a constant barrage of lies and hateful comments. The president acts like he does not respect democracy or the rule of law. His presidency has become a reality game show, driven by his primal need to achieve the best ratings and wins— for himself. He does not respect women, minorities, or immigrants; he often doesn't appear to respect even his wife. To him, a critical news story is "FAKE NEWS." To him, all our intelligence agencies are corrupt. He shuns preparation for meetings with foreign heads of state. He tells his supporters how he alone can fix the economy, yet his policies will hurt them and help line his pockets, as well as those of rich people like him. And then there's his ongoing attempt to cripple millions of Americans by taking away their health insurance.

Early in the first week of his presidency, I posted on my new personal Instagram account an innocuous photograph of President Obama by the Resolute Desk. Underneath, I wrote a snarky caption, saying I liked the old drapes better than the gaudy new ones that had recently been installed.

Yes, I was pissed off that the new president had been elected. I was also appalled by the curtains themselves: the redecorated Oval Office, with its emphasis on gold, made the White House look like his personal palace. In fact, it is the *people's* house.

The overwhelming positive reaction to my post caught me by surprise—and one comment left me bewildered: "Pete is dropping shade with a comment on drapes."

What is shade? I wondered.

During the next few days, I posted more photographs of President Obama, using subtle captions that contrasted with something the new president had done.

Dozens of reporters asked to interview me. I turned them down. They did their stories anyway. A few wrote that I was "throwing shade" at the new president.

So, finally, I googled "throwing shade" and Merriam-Webster explained it to me: it's a "subtle, sneering expression of contempt for or disgust with someone— sometimes verbal, and sometimes not."

Yup, that's what I was doing—throwing shade. And I kept it up for the first 500 days of the new administration, and I plan to keep going long after you've read this book. My comments are often humorous, and I'd even say they are more or less respectful. They are certainly more respectful than the tweets coming from this president.

I also try to make subtle comments with my Instagram posts without directly revealing what the current president has said or done. Many people tell me they see my posts and then try to find out what they missed in the news.

In this book, I take a turn to full transparency and let it all hang out. In the pages that follow, you will see adaptations of my original posts matched up directly with what inspired them—a presidential tweet and/or the news that caught my attention in the first place. You can call it shade. I just call it the truth.

I hope you laugh, and maybe even cry, as you read this book. During the past 18 months, outrage has bubbled up inside me. I have become more and more appalled at the person that we, with help from Russia, elected to represent our nation. With this book, I'm standing up and shouting out. I can't be subtle any longer.

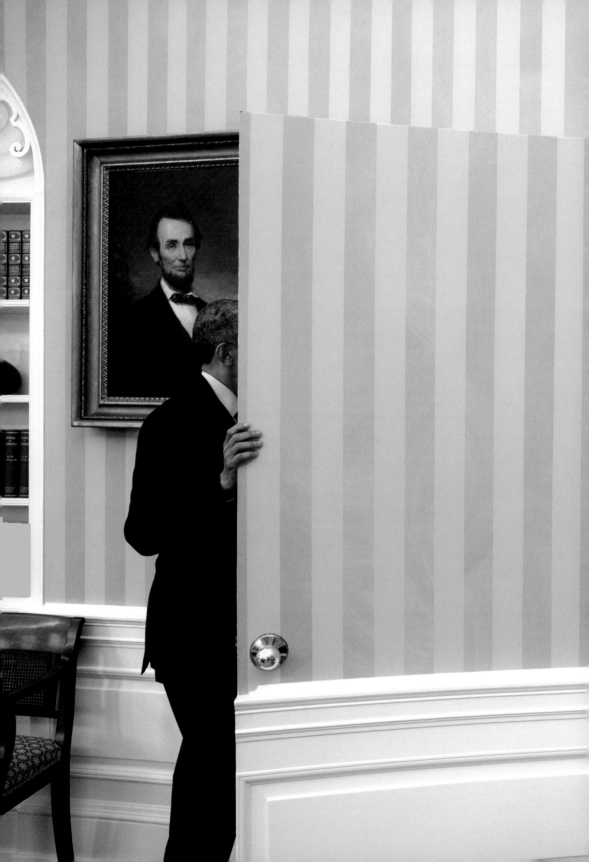

"You saw that—packed. I get up this morning, I turn on one of the networks and they show an empty field. I said wait a minute, I made a speech. I looked out the field was, it looked like a million, a million and a half people, they showed a field where there was practically nobody standing there."

President Donald J. Trump
Remarks at CIA headquarters, January 21, 2017

"This was the largest audience to ever witness an inauguration, period!"

White House Press Secretary Sean Spicer
During his first press briefing, January 21, 2017

petesouza ✔ The biggest crowd in history was really on January 20, 2009. HUGE ! ▶

January 21, 2017

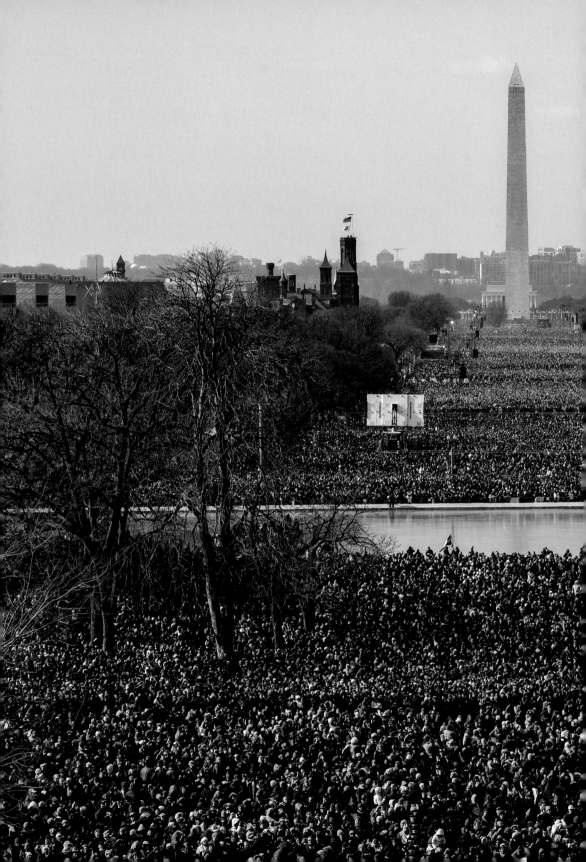

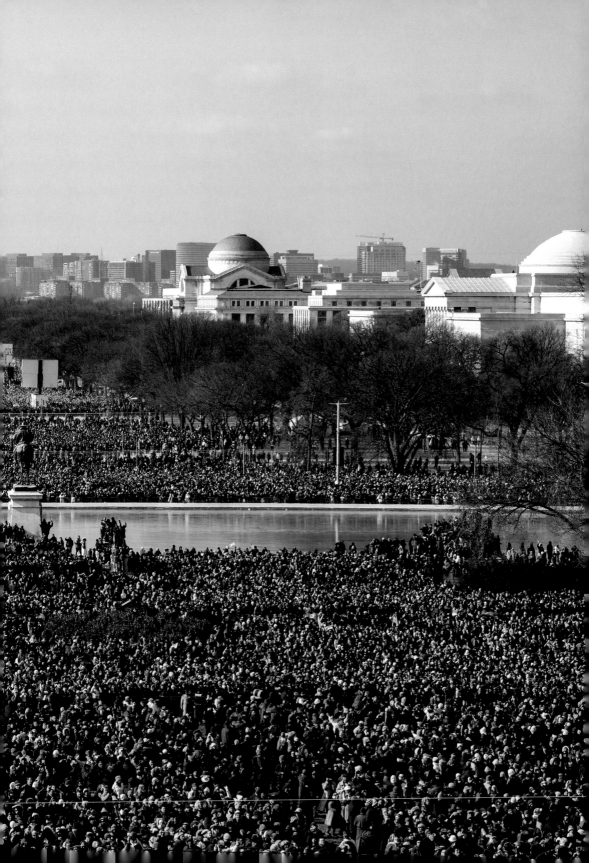

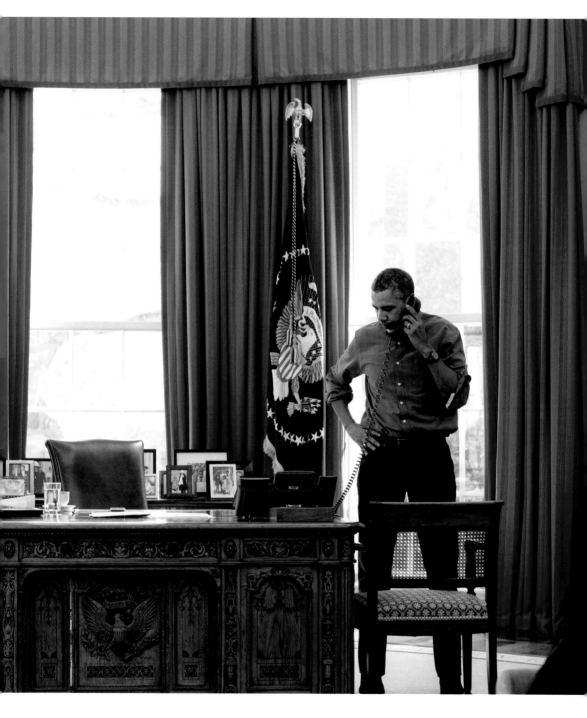

petesouza ✓ I like these drapes better than the gaudy new gold ones.

January 22, 2017

Trump Bars Refugees and Citizens of 7 Muslim Countries

The New York Times, January 27, 2017

Donald J. Trump ✓
@realDonaldTrump

There is nothing nice about searching for terrorists before they can enter our country. This was a big part of my campaign. Study the world!

January 30, 2017 7:27 AM

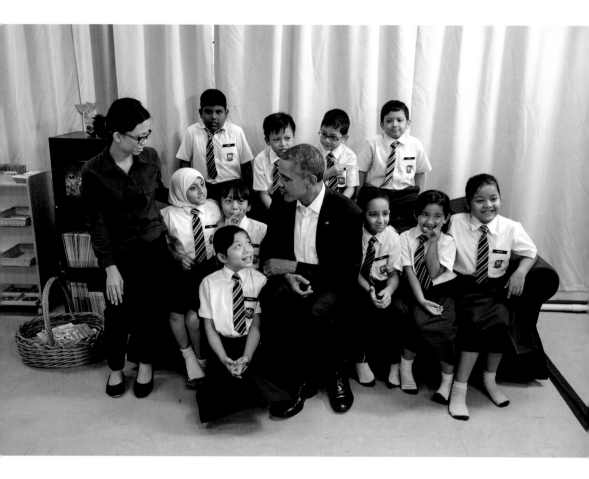

petesouza ✔ Talking with young refugees at a Dignity for Children Foundation classroom in Malaysia.

January 29, 2017

Donald J. Trump ✔
@realDonaldTrump

The dishonest media does not report that any money spent on building the Great Wall (for sake of speed), will be paid back by Mexico later!

January 6, 2017 6:19 AM

Mexico's President Cancels Meeting with Trump Over Wall

Azam Ahmed
The New York Times, January 26, 2017

MEXICO CITY—President Donald J. Trump's decision to build a wall along the southern border escalated into a diplomatic standoff on Thursday, with Mexico's president publicly canceling a scheduled meeting at the White House and Mr. Trump firing back, accusing Mexico of burdening the United States with illegal immigrants, criminals and a trade deficit...

Donald J. Trump ✔
@realDonaldTrump

...If Mexico is unwilling to pay for the badly needed wall, then it would be better to cancel the upcoming meeting.

January 26, 2017 8:55 AM

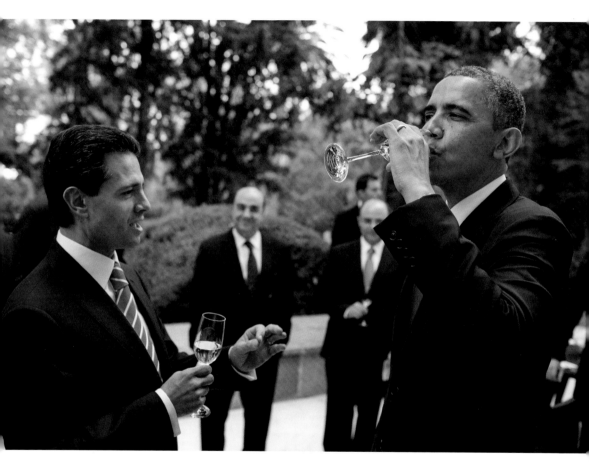

petesouza ✔ President Obama samples some tequila with President Enrique
Peña Nieto of Mexico in 2013. Though immigration was always a topic
of discussion between the two, building a "Great Wall" to separate
two neighbors was not.

January 31, 2017

Trump and Staff Rethink Tactics After Stumbles

Glenn Thrush and Maggie Haberman
The New York Times, February 5, 2017

WASHINGTON—President Trump loves to set the day's narrative at dawn, but the deeper story of his White House is best told at night.

Aides confer in the dark because they cannot figure out how to operate the light switches in the cabinet room. Visitors conclude their meetings and then wander around, testing doorknobs until finding one that leads to an exit.

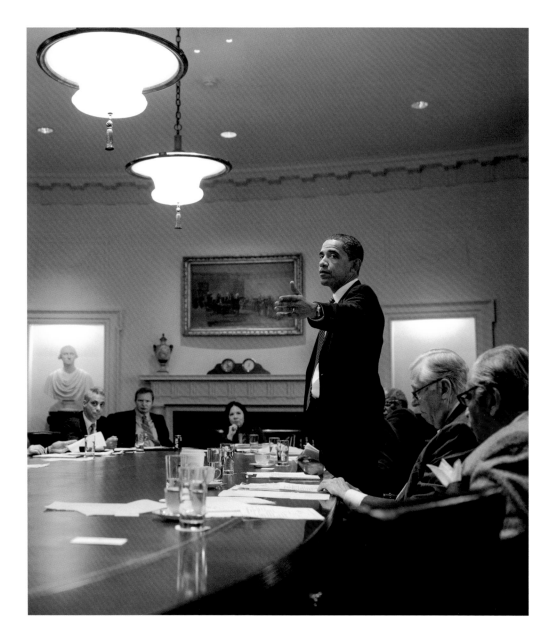

petesouza ✔ Those damn lights.

February 6, 2017

Donald J. Trump ✓
@realDonaldTrump

Just leaving Florida. Big crowds of enthusiastic supporters lining the road that the FAKE NEWS media refuses to mention. Very dishonest!

February 12, 2017 5:19 PM

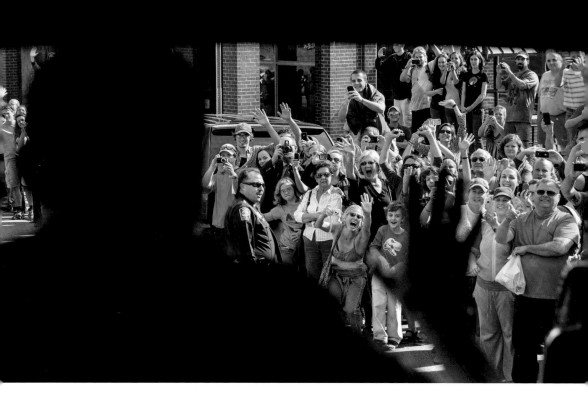

petesouza ✓ Thousands of real people line the motorcade route in North Carolina as President Obama waves from the front of a bus in 2011.

February 12, 2017

Missile Crisis by Candlelight: Donald Trump's Use of Mar-a-Lago Raises Security Questions

Julian Borger
The Guardian, February 13, 2017

Nothing befitted Donald Trump more than his first real national security scare.

The urgent consultation with Japanese prime minister, Shinzo Abe, about a provocative North Korean missile launch, was played out by candlelight against a backdrop of hotel muzak, high-paying guests and low-paid waiters.

One of the guests, retired investor Richard DeAgazio, posted pictures of the scene on his Facebook page showing aides clustered around the two men on the dining terrace of Trump's Palm Beach country club, Mar-a-Lago.

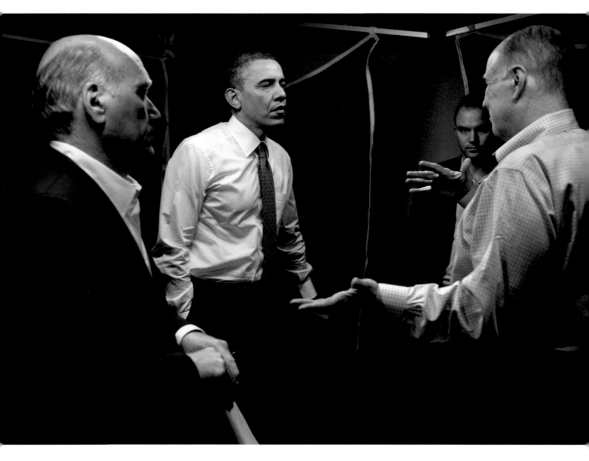

petesouza ✔ When we were on the road, national security discussions and head of state phone calls were conducted in a private, secure location set up on-site. Everyone had to leave their BlackBerrys outside the area. In this photo, which was taken in March 2011, the President holds a discussion in El Salvador following a conference call with his full National Security team.

February 13, 2017

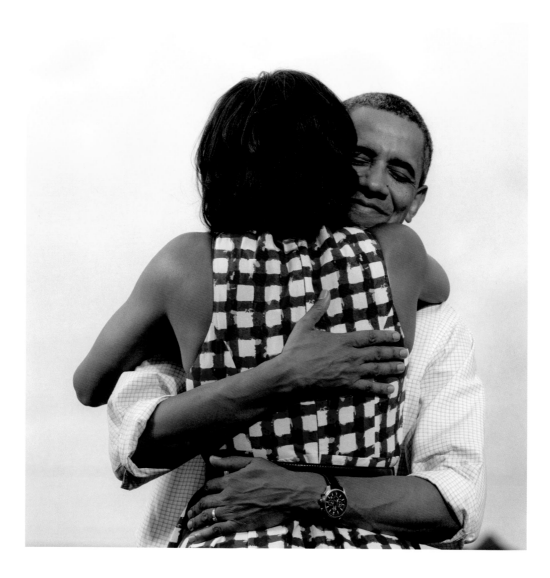

petesouza � Happy Valentine's Day. Hug someone you love.

February 14, 2017

Trump Revokes Obama Guidelines on Transgender Bathrooms

Daniel Trotta
Reuters, February 22, 2017

President Donald Trump's administration on Wednesday revoked landmark guidance to public schools letting transgender students use the bathrooms of their choice, reversing a signature initiative of former Democratic President Barack Obama.

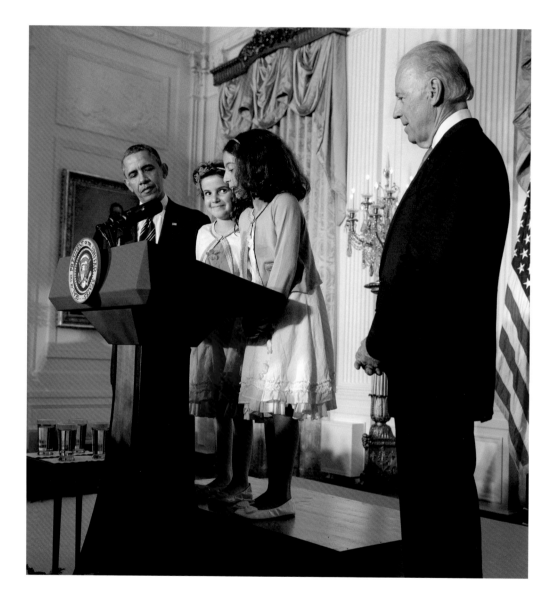

petesouza ● President Obama and Vice President Joe Biden listen as Zea and Luna Weiss-Wynne introduce them at a reception for LGBT Pride Month in 2013. During the administration, this was an annual celebration dedicated to lesbian, gay, bisexual, and transgender rights. The girls, daughters of two gay moms, had written to the President, urging his continued support of the LGBTQ community.

February 23, 2017

White House Bars Some News Organizations from Briefing

Ayesha Rascoe
Reuters, February 24, 2017

The White House excluded several major U.S. news organizations, including some it has criticized, from an off-camera briefing held by the White House press secretary on Friday.

Reporters for CNN, The New York Times, Politico, The Los Angeles Times and BuzzFeed were not allowed into the session in the office of press secretary Sean Spicer.

"And I want you all to know that we are fighting the fake news. It's fake—phony, fake." [APPLAUSE.] "A few days ago, I called the fake news 'the enemy of the people'— and they are. They are the enemy of the people. Because they have no sources, they just make them up when there are none…"

President Donald J. Trump
Remarks at the Conservative Political Action Conference, February 24, 2017

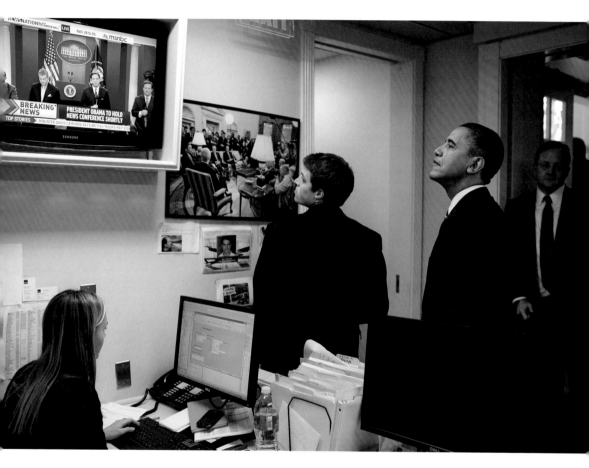

petesouza ✓ Waiting with press aides Caroline Hughes and Ben Finkenbinder for the start of a news conference in 2010. Press Secretary Robert Gibbs is at right. Reporters from CNN, *The New York Times, Politico, The Los Angeles Times, BuzzFeed,* and, yes, even Fox News were all invited.

February 24, 2017

Donald J. Trump ✔
@realDonaldTrump

How low has President Obama gone to tapp my phones during the very sacred election process. This is Nixon/Watergate. Bad (or sick) guy!

March 4, 2017 7:02 AM

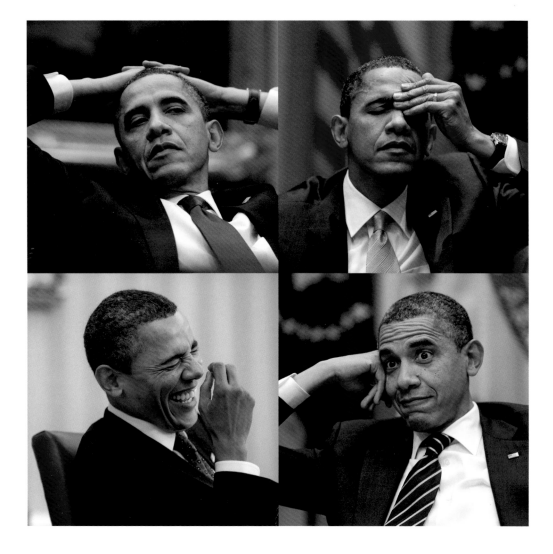

petesouza ✔ Say what!?

March 5, 2017

Donald J. Trump ✔
@realDonaldTrump

We must keep "evil" out of our country!

February 3, 2017 6:08 PM

Trump's New Travel Ban Blocks Migrants from Six Nations, Sparing Iraq

Glenn Thrush
The New York Times, March 6, 2017

President Trump signed an executive order on Monday blocking citizens of six predominantly Muslim countries from entering the United States, the most significant hardening of immigration policy in generations, even with changes intended to blunt legal and political opposition.

The order was revised to avoid the tumult and protests that engulfed the nation's airports after Mr. Trump signed his first immigration directive on Jan. 27. That order was ultimately blocked by a federal appeals court.

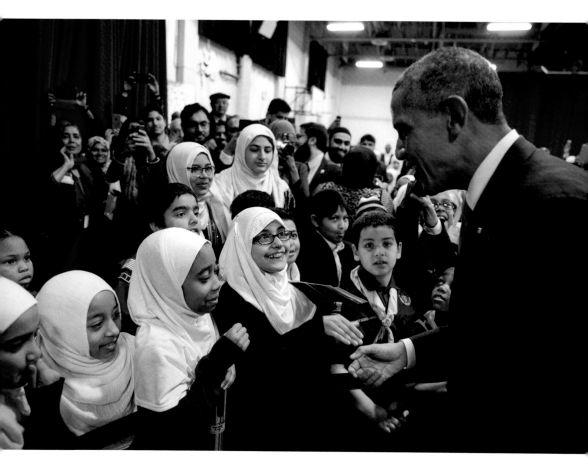

petesouza ✔ President Obama shaking hands after his remarks in 2016 at the Islamic Society of Baltimore mosque and Al-Rahmah School in Baltimore, Maryland.

March 6, 2017

In First Trump-Merkel Meeting, Awkward Body Language and a Quip

Jeff Mason and Andreas Rinke
Reuters, March 17, 2017

The first face-to-face meeting between U.S. President Donald Trump and German Chancellor Angela Merkel started awkwardly on Friday and ended even more oddly, with a quip by Trump about wiretapping that left the German leader visibly bewildered…

Trump and Merkel shook hands when she arrived at the White House but did not do so in the Oval Office, where she frequently leaned towards him while he stared straight ahead, sitting with his legs apart and hands together.

Donald J. Trump ✔
@realDonaldTrump

Despite what you have heard from the FAKE NEWS, I had a GREAT meeting with German Chancellor Angela Merkel. Nevertheless, Germany owes…vast sums of money to NATO & the United States must be paid more for the powerful, and very expensive, defense it provides to Germany!

March 18, 2017 8:23 AM

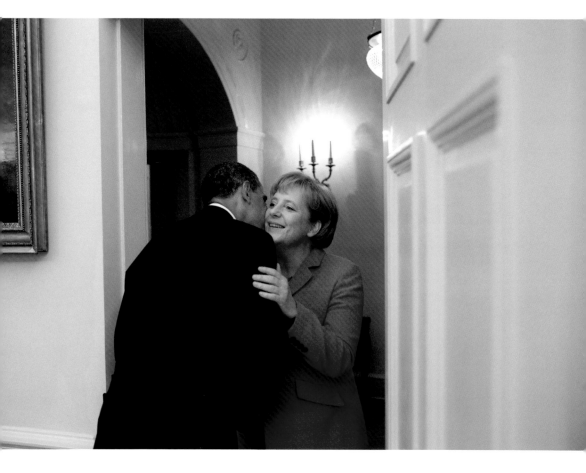

petesouza ✔ First time meeting Angela Merkel in 2009.

March 17, 2017

Donald J. Trump ✔
@realDonaldTrump

After seven horrible years of ObamaCare (skyrocketing premiums & deductibles, bad healthcare), this is finally your chance for a great plan!

March 24, 2017 7:14 AM

In Major Defeat for Trump, Push to Repeal Health Law Fails

The New York Times, March 24, 2017

"You know, I said the other day when President Obama left, '17, he knew he wasn't going to be here. '17 is going to be a very, very bad year for Obamacare, very, very bad. You're going to have explosive premium increases, and your deductibles are so high people don't even get to use it."

President Donald J. Trump
Remarks in the Oval Office, March 24, 2017

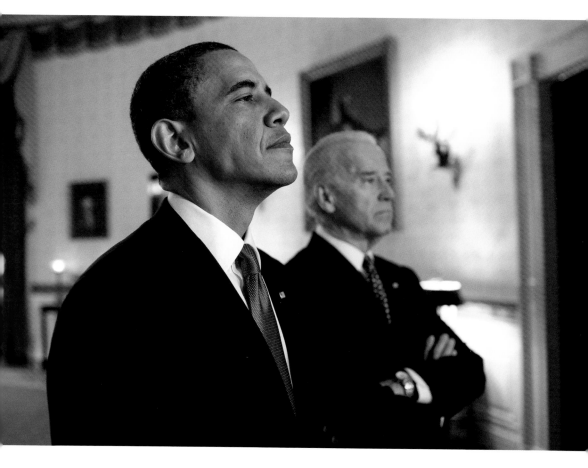

petesouza ✅ Seven years ago today, President Obama signed the Affordable Care Act into law. Here he and Vice President Biden wait to be introduced for the signing ceremony. Nearly 20 million more Americans now have health insurance than did prior to the ACA.

March 23, 2017

6 Obama Climate Policies That Trump Orders Change

Madison Park
CNN, March 28, 2017

President Donald Trump on Tuesday signed an executive order curbing the federal government's enforcement of climate regulations, a move that represents a sharp reversal from his predecessor's position.

The Obama administration put in place a number of programs that attempted to address the impact of climate change, including rising sea levels and temperatures.

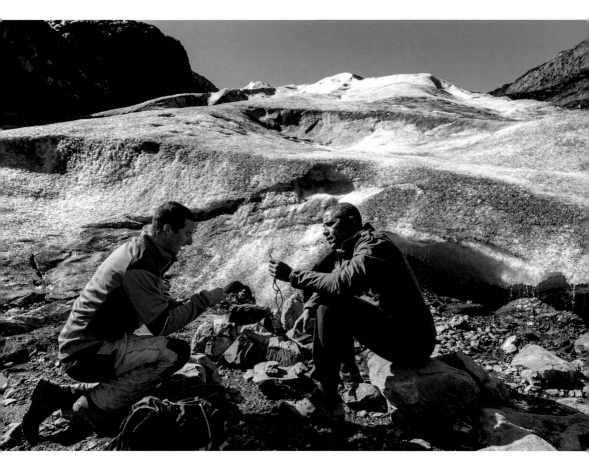

petesouza ✔ President Obama talks climate change with Bear Grylls at a melting glacier in Alaska.

March 28, 2017

Donald Trump White House to Host Seder

Time, April 10, 2017

Donald Trump Skips White House Passover Seder

The Huffington Post, April 11, 2017

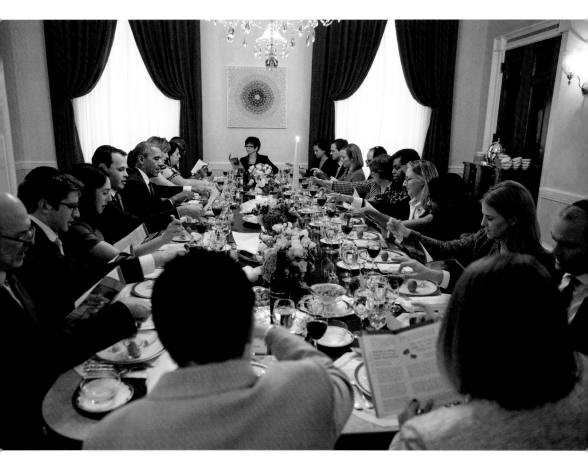

petesouza ✿ The 2016 Seder at the White House.

April 10, 2017

Trump White House Will Not Make Visitor Logs Public, Break from Obama Policy

Reuters, April 14, 2017

petesouza ✓ Bet he was noted in the visitor logs.

April 14, 2017

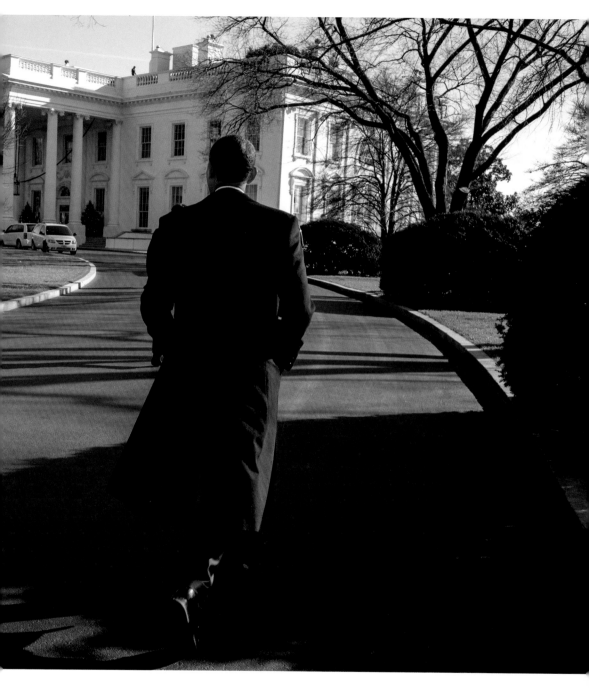

petesouza ✔ It's not what you think. He is returning to the White House...
but this is from 2011.

April 17, 2017

Ted Nugent and Sarah Palin Mock Hillary Clinton Portrait During White House Trip

The Kansas City Star, April 20, 2017

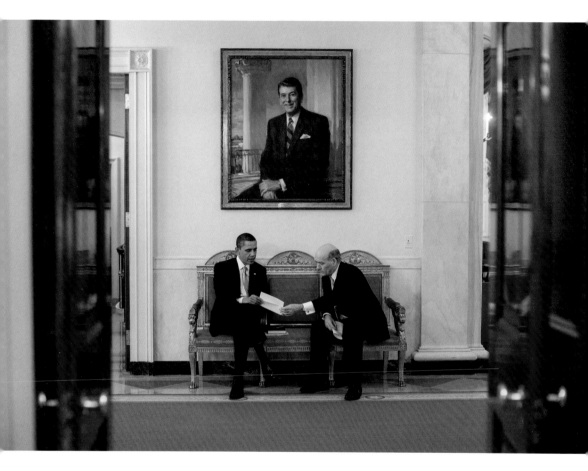

petesouza ✓ Being respectful. President Obama with Chief of Staff Bill Daley underneath the official portrait of President Ronald Reagan.

April 20, 2017

Donald J. Trump ✓
@realDonaldTrump

Congratulations to our new Attorney General, @SenatorSessions!

February 8, 2017 8:05 PM

Donald J. Trump ✓
@realDonaldTrump

I will be interviewed on @foxandfriends at 6:00 A.M. Enjoy!

February 27, 2017 9:43 PM

Donald J. Trump ✓
@realDonaldTrump

Mainstream (FAKE) media refuses to state our long list of achievements, including 28 legislative signings, strong borders & great optimism!

April 29, 2017 12:39 PM

Donald J. Trump ✓
@realDonaldTrump

MAKE AMERICA GREAT AGAIN!

February 4, 2017 9:26 AM

Donald J. Trump ✓
@realDonaldTrump

The failing @nytimes has been wrong about me from the very beginning. Said I would lose the primaries, then the general election. FAKE NEWS!

January 28, 2017 8:04 AM

Donald J. Trump ✓
@realDonaldTrump

I don't know Putin, have no deals in Russia, and the haters are going crazy - yet Obama can make a deal with Iran, #1 in terror, no problem!

February 7, 2017 7:11 AM

Donald J. Trump ✓
@realDonaldTrump

Had a great meeting at CIA Headquarters yesterday, pa house, paid great respect to long standing ovations, ama people. WIN!

January 22, 2017 7:35 AM

Donald J. Trump ✓
@realDonaldTrump

know Mark Cuban well. He backed me big-time but I asn't interested in taking all of his calls.He's not smart nough to run for president!

bruary 12, 2017 8:23 AM

Donald J. Trump ✓
@realDonaldTrump

Congratulations to @FoxNews for being number one inauguration ratings. They were many times higher th FAKE NEWS @CNN - public is smart!

January 24, 2017 9:16 PM

Donald J. Trump ✓
@realDonaldTrump

Terrible! Just found out that Obama had my "wires tapped" in Trump Tower just before the victory. Nothing found. This is McCarthyism!

March 4, 2017 6:35 AM

Wow, television ratings just o 31 million people watched th Inauguration, 11 million more than the very good ratings fro years ago!

January 22, 2017 7:51 AM

Donald J. Trump ✓
@realDonaldTrump

I will be asking for a major investigation into VOTER FRAUD, including those registered to vote in two states, those who are illegal and....

January 25, 2017 7:10 AM

Donald J. Trump ✓
@realDonaldTrump

When will Sleepy Eyes Chuck Todd and @NBCNews start talking about the Obama SURVEILLANCE SCANDAL and stop with the Fake Trump/Russia story?

April 1, 2017 7:43 AM

Donald J. Trump ✓
@realDonaldTrump

Don't let the FAKE NE tell you that there is b infighting in the Trump Admin. We are gettin along great, and gettin major things done!

Tweets from @realDonaldTrump during his first 100 days.

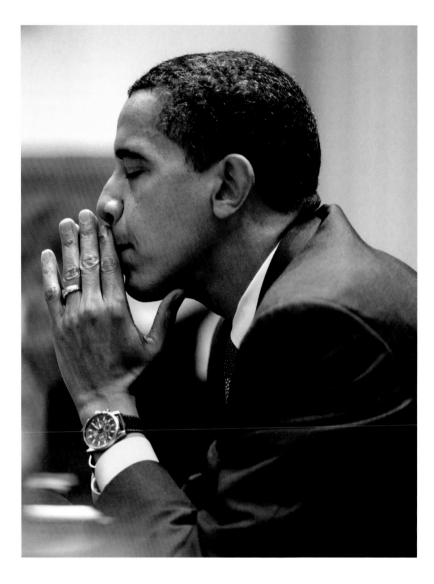

petesouza ✔ Some people forget the dire economic situation the country faced as President Obama began his Presidency. This photograph is from a meeting in late January 2009 as he dealt with the crisis. See more photos from the first 100 days. ▶

April 28, 2017

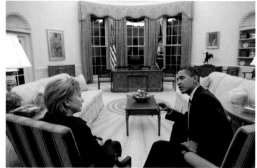

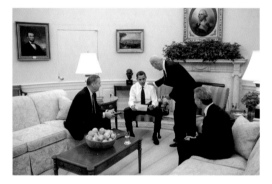

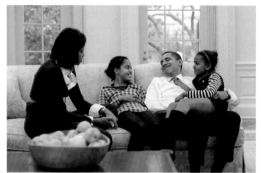

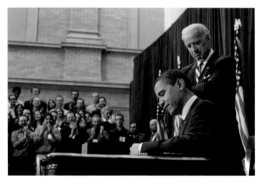

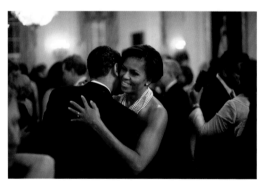

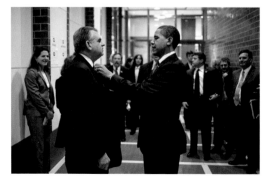

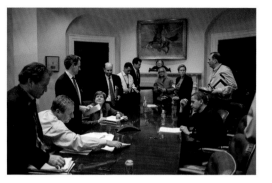

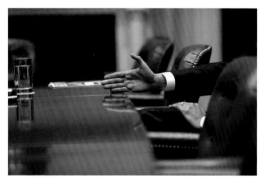

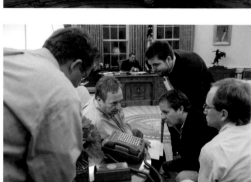

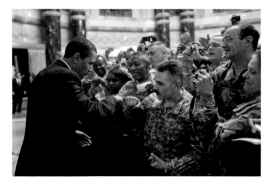

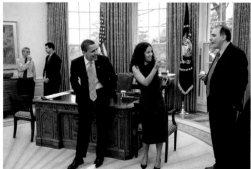

Donald J. Trump ✓
@realDonaldTrump

The reason I am staying in Bedminster, N.J., a beautiful community, is that staying in NYC is much more expensive and disruptive. Meetings!

May 6, 2017 5:39 PM

petesouza ✔ Stuck in meetings! At Sunnylands in Rancho Mirage, California, 2016. ▶

May 7, 2017

Donald J. Trump ✔
@realDonaldTrump

Russia must be laughing up their sleeves watching
as the U.S. tears itself apart over a Democrat EXCUSE
for losing the election.

May 11, 2017 3:34 PM

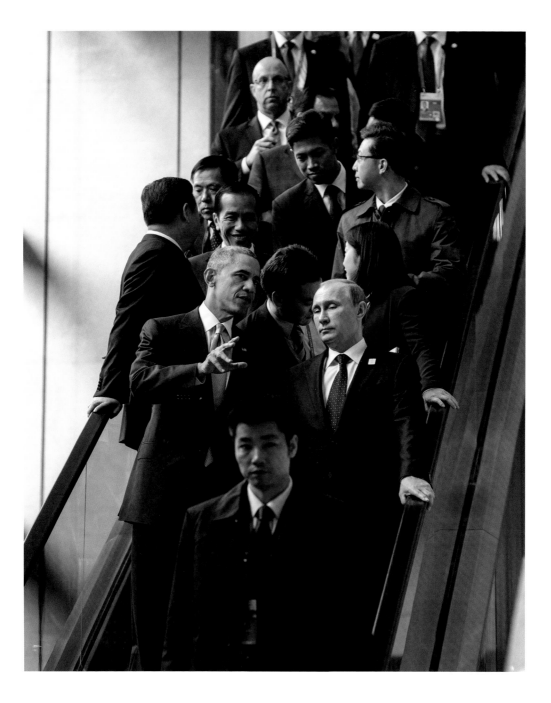

petesouza ✅ Not much laughter happening here (Beijing, China, 2014).

May 11, 2017

"But regardless of the recommendation, I was going to fire Comey… And in fact, when I decided to just do it, I said to myself, I said, You know, this Russia thing with Trump and Russia is a made-up story. It's an excuse by the Democrats for having lost an election that they should have won."

President Donald J. Trump
Interview with NBC's Lester Holt, May 11, 2017

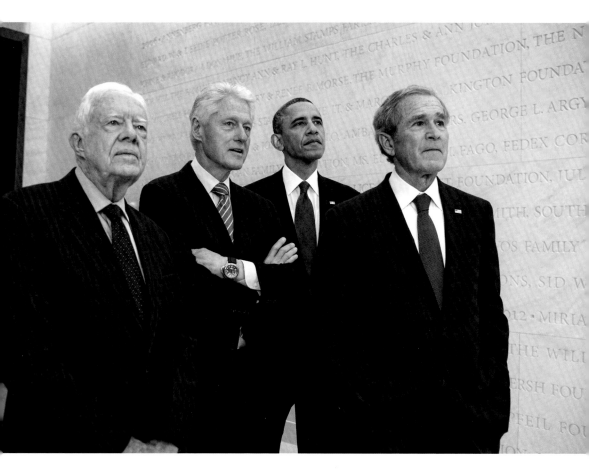

petesouza ✔ Wonder what they are thinking?

May 11, 2017

Trump Revealed Highly Classified Information to Russian Foreign Minister and Ambassador

The Washington Post, May 15, 2017

petesouza ✔ The top secret Presidential Daily Brief on a secure, modified iPad.

May 15, 2017

"Look at the way I've been treated lately—especially by the media. No politician in history—and I say this with great surety—has been treated worse or more unfairly… I've accomplished a tremendous amount in a very short time as President…I've loosened up the strangling environmental chains wrapped around our country and our economy, chains so tight that you couldn't do anything…God bless the Coast Guard…Good luck. Enjoy your life."

President Donald J. Trump
Remarks at the U.S. Coast Guard Academy, May 17, 2017

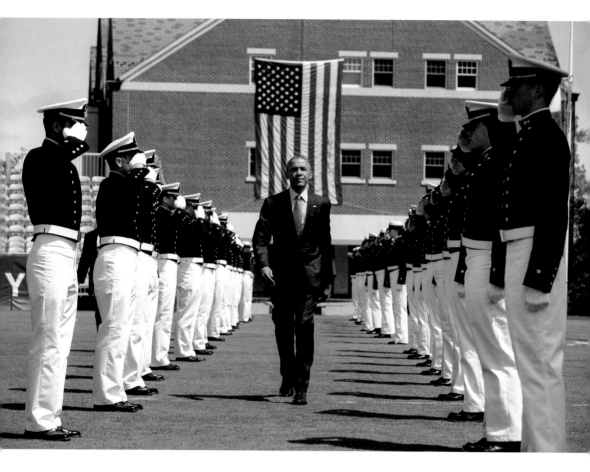

petesouza ✔ President Obama at the U.S. Coast Guard Academy in 2015: "That's why confronting climate change is now a key pillar of American global leadership. When I meet with leaders around the world, it's often at the top of our agenda—a core element of our diplomacy. And you are part of the first generation of officers to begin your service in a world where the effects of climate change are so clearly upon us. It will shape how every one of our services plan, operate, train, equip, and protect their infrastructure, their capabilities, today and for the long term."

May 17, 2017

Robert Mueller, Former F.B.I. Director, Is Named Special Counsel for Russia Investigation

The New York Times, May 17, 2017

Donald J. Trump ✓
@realDonaldTrump

With all of the illegal acts that took place in the Clinton campaign & Obama Administration, there was never a special councel appointed!

May 18, 2017 6:39 AM

Donald J. Trump ✓
@realDonaldTrump

This is the single greatest witch hunt of a politician in American history!

May 18, 2017 6:52 AM

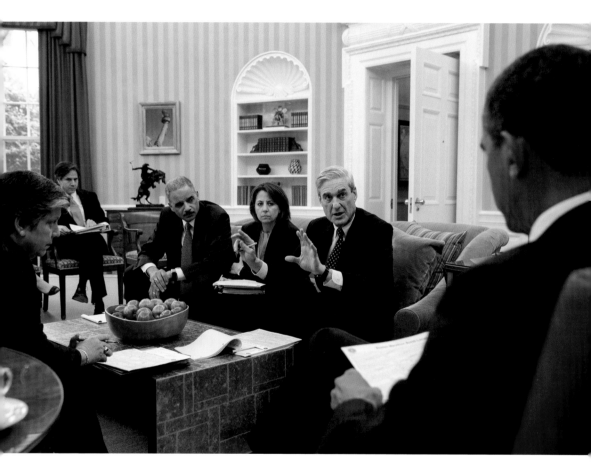

petesouza ✔ Robert Mueller, then the FBI director, briefs President Obama after the Boston Marathon bombing in 2013. From left to right, Homeland Security Secretary Janet Napolitano, Deputy Chief of Staff Alyssa Mastromonaco, Deputy National Security Advisor Tony Blinken, Attorney General Eric Holder, and Homeland Security Advisor Lisa Monaco.

May 17, 2017

Comey, Unsettled by Trump, Is Said to Have Wanted Him Kept at a Distance

Michael S. Schmidt
The New York Times, May 18, 2017

Mr. Comey—who is 6 feet 8 inches tall and was wearing a dark blue suit that day—told Mr. Wittes that he tried to blend in with the blue curtains in the back of the room, in the hopes that Mr. Trump would not spot him and call him out…

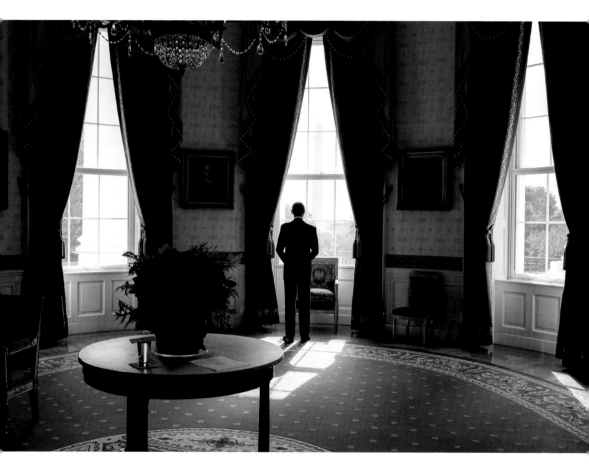

petesouza ✓ I'm trying to envision someone six inches taller than President Obama hiding behind the curtains in the Blue Room.

May 19, 2017

Melania Slaps Away President Trump's Hand on Tel Aviv Tarmac at Start of Israel Trip

YouTube, May 22, 2017

petesouza ✔ Holding hands during the 50th anniversary of the Selma March.

May 23, 2017

Pope Looks Glum After Vatican Meeting with Donald Trump

The Guardian, May 24, 2017

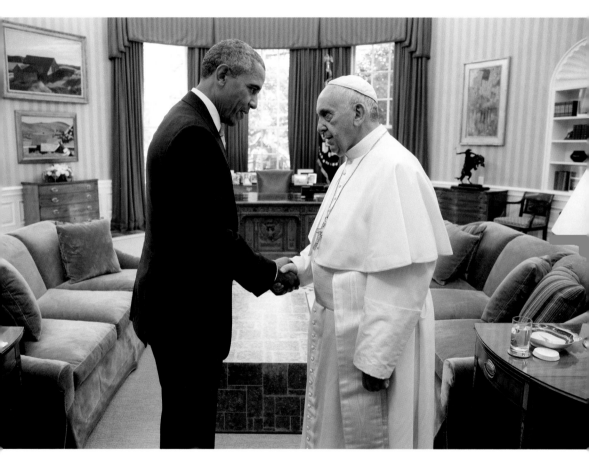

petesouza ✔ Mutual admiration, 2015.

May 24, 2017

President Trump Insults Germany, Shoves a Prime Minister, Draws Smirks from World Leaders in Bizarre NATO Visit

Adam Edelman
New York Daily News, May 25, 2017

In a span of just a few hours, Trump shoved a head of state, awkwardly shook hands with another, faced accusations of leaking intelligence and lectured NATO members about paying more for their defense.

If that wasn't enough, it was revealed by day's end that Trump had insulted Germany during a meeting—calling them "bad, very bad."

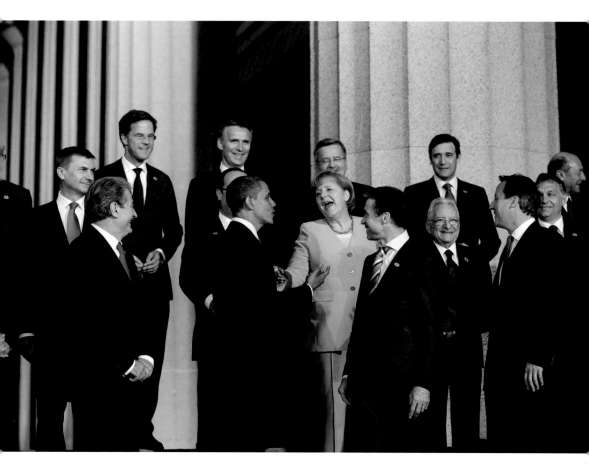

petesouza ✔ Laughter with German Chancellor Angela Merkel at the NATO summit in 2012. No jostling or leaking of classified intelligence either.

May 25, 2017

Donald J. Trump ✔
@realDonaldTrump

Despite the constant negative press covfefe

May 30, 2017 11:06 PM

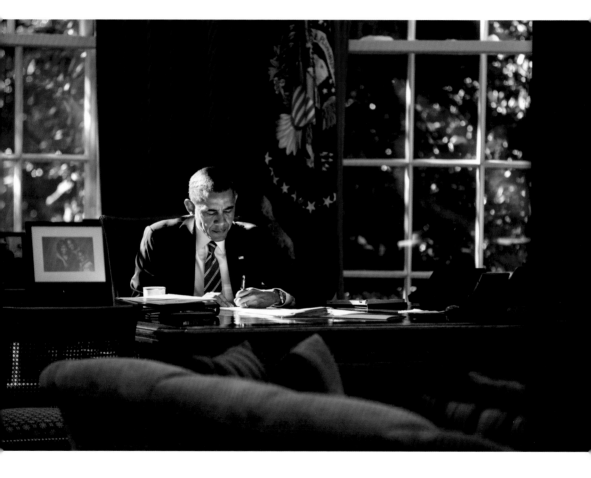

petesouza ✓ C-O-V-F...

May 31, 2017

Trump Announces U.S. Will Exit Paris Climate Deal, Sparking Criticism at Home and Abroad

The Washington Post, June 1, 2017

Donald J. Trump ✔
@realDonaldTrump

MAKE AMERICA GREAT AGAIN!

June 1, 2017 8:00 PM

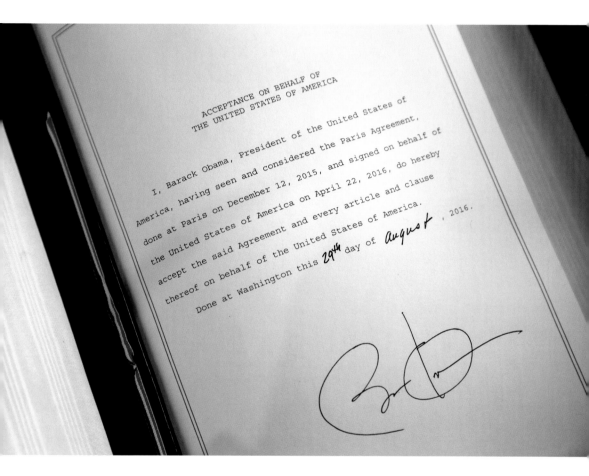

petesouza ✔ President Obama signed the Paris Climate Agreement in 2016. I'm thinking of the poignant words of Woody Guthrie: "This land is your land"... ▶

June 1, 2017

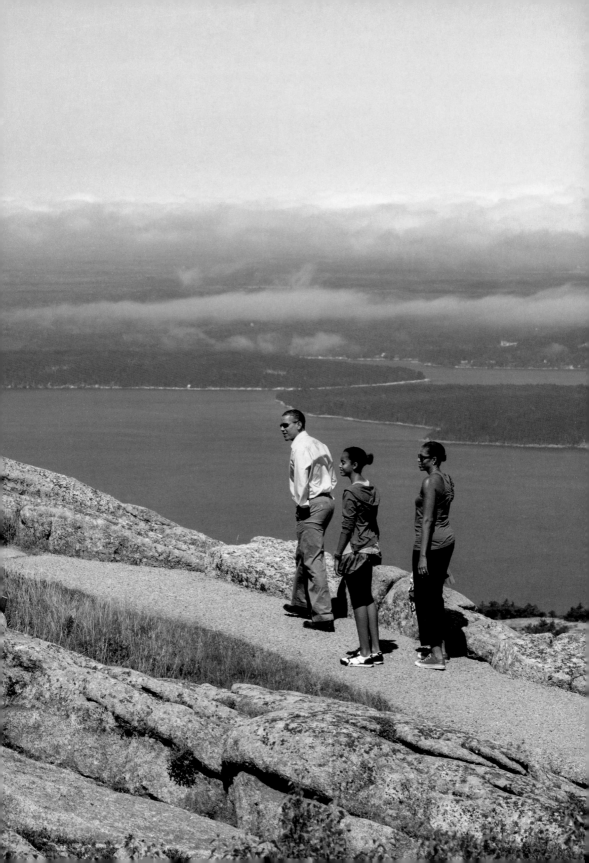

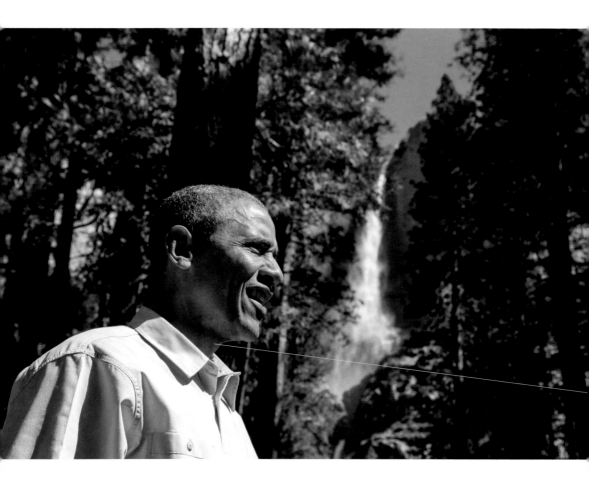

petesouza ✔ "This land is my land"...

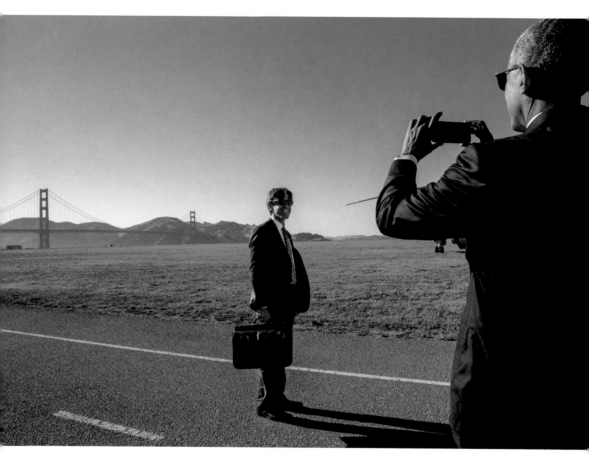

petesouza ✔ "From California to the New York island"...

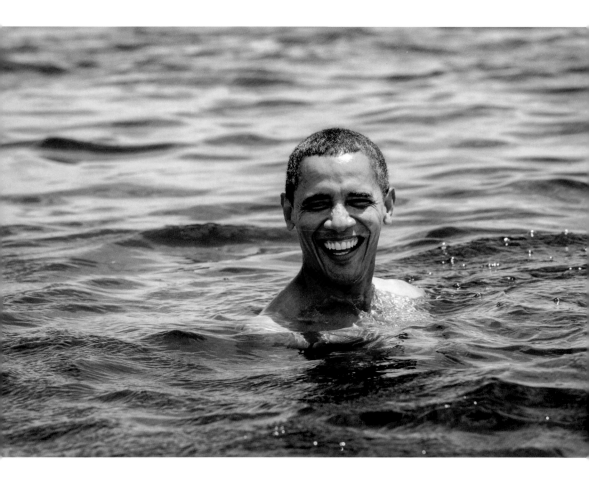

petesouza ✓ "From the redwood forest to the Gulf Stream waters"...

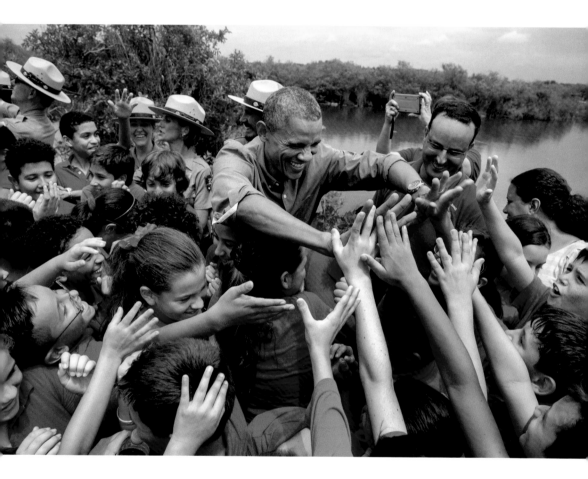

petesouza ✓ "This land was made for you and me."

Donald J. Trump ✔
@realDonaldTrump

It is time to rebuild OUR country, to bring back OUR jobs, to restore OUR dreams, & yes, to put #AmericaFirst!

June 9, 2017 5:52 PM

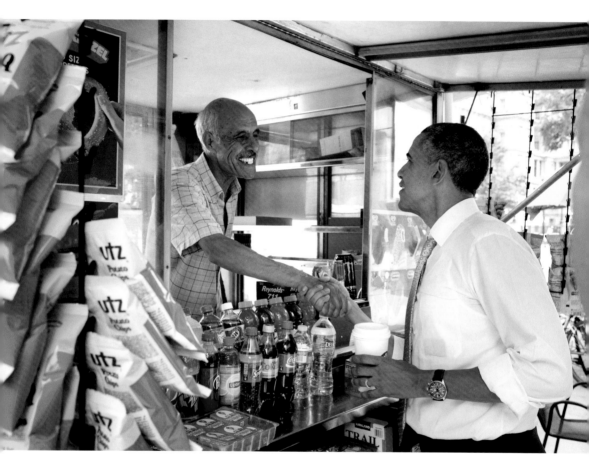

petesouza ✔ Three years ago today: President Obama greets vendor Saied E. Abedy (an Afghan immigrant) while walking back to the White House from Starbucks on Pennsylvania Avenue in Washington, D.C. We later hung a jumbo print of this in the West Wing when we heard that a staff member had invited Saied and his family on a White House tour.

June 9, 2017

Trump's Cabinet, with a Prod, Extols the "Blessing" of Serving Him

Julie Hirschfeld Davis
The New York Times, June 12, 2017

WASHINGTON—One by one, they praised President Trump, taking turns complimenting his integrity, his message, his strength, his policies. Their leader sat smiling, nodding his approval.

"The greatest privilege of my life is to serve as vice president to the president who's keeping his word to the American people," Mike Pence said, starting things off.

"I am privileged to be here—deeply honored—and I want to thank you for your commitment to the American workers," said Alexander Acosta, the secretary of labor.

Sonny Perdue, the agriculture secretary, had just returned from Mississippi and had a message to deliver. "They love you there," he offered, grinning across the antique table at Mr. Trump.

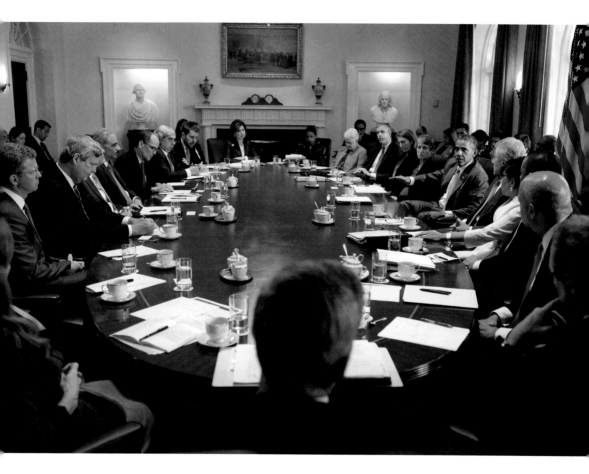

petesouza ✅ A cabinet meeting where officials didn't have to praise their boss.

June 13, 2017

Donald J. Trump ✔
@realDonaldTrump

The real story is that President Obama did NOTHING after being informed in August about Russian meddling.

June 26, 2017 7:59 AM

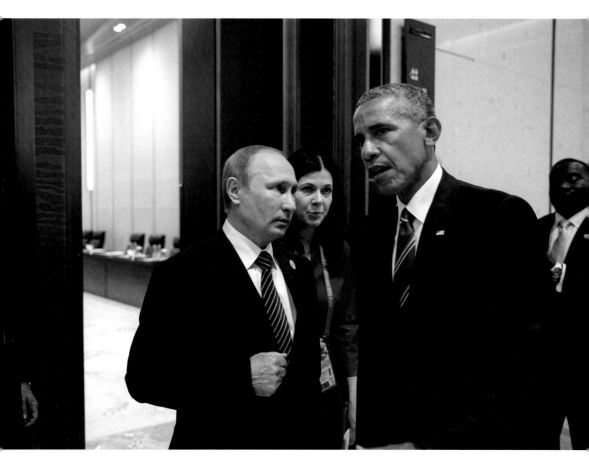

petesouza ✔ On September 5, 2016, President Obama confronted Vladimir Putin about meddling in our election.

June 26, 2017

Donald J. Trump ✓
@realDonaldTrump

...Then how come low I.Q. Crazy Mika, along with
Psycho Joe, came...

June 29, 2017 7:52 AM

...to Mar-a-Lago 3 nights in a row around New Year's
Eve, and insisted on joining me. She was bleeding badly
from a face-lift. I said no!

June 29, 2017 7:58 AM

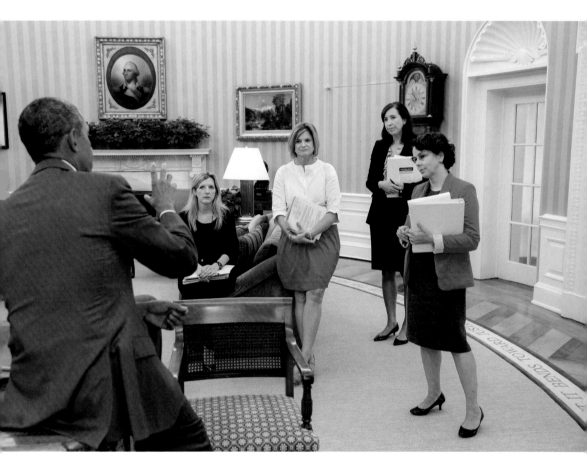

petesouza ✔ Respect for women. President Obama strategizes with aides Kathy Ruemmler, Jennifer Palmieri, Katie Beirne Fallon, and Cecilia Muñoz in 2013. ▶

June 29, 2017

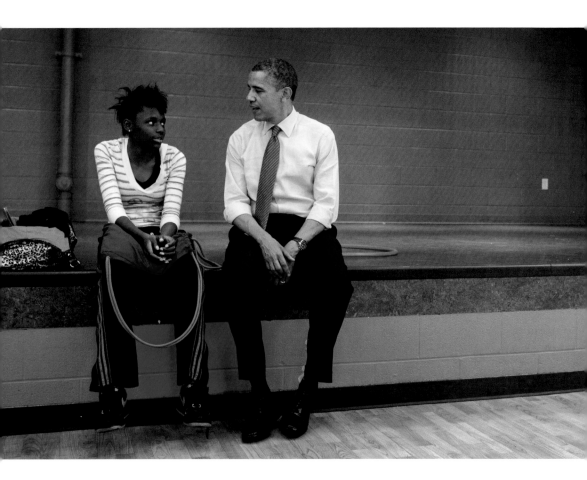

petesouza ✔ President Obama talks with a young woman during a stop at the Boys and Girls Club of Cleveland, Ohio, in 2012.

June 29, 2017

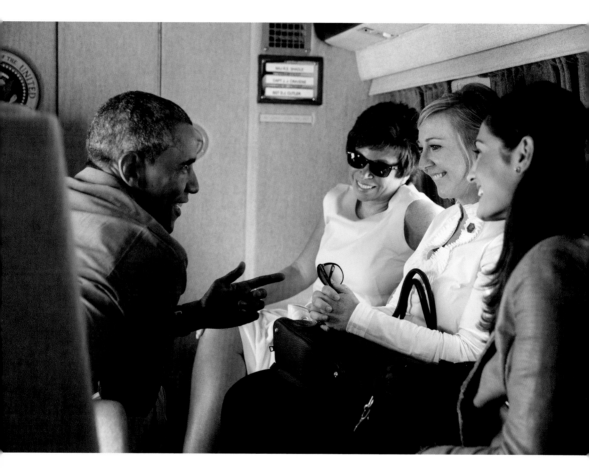

petesouza ✔ Riding the helicopter in 2015 with aides Valerie Jarrett, Anita Decker Breckenridge, and Jennifer Friedman.

June 29, 2017

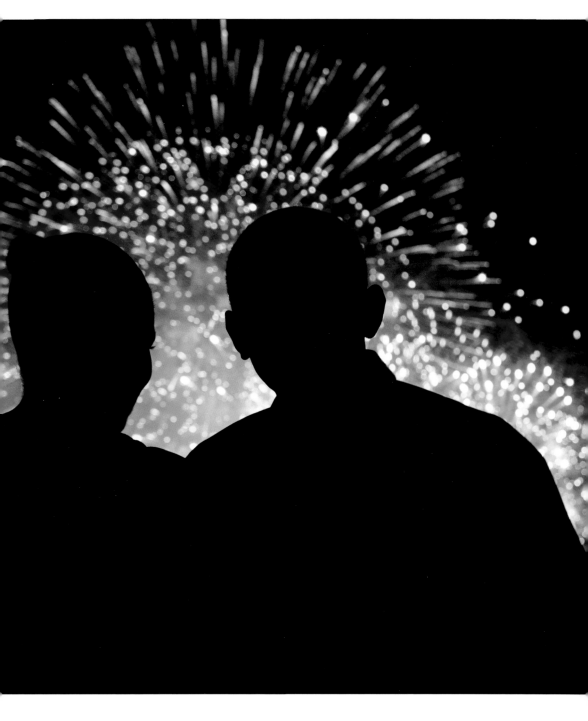

petesouza ✓ Celebrating the Fourth of July with the First Lady at the White House.

July 4, 2017

Russian Dirt on Clinton?
"I Love It," Donald Trump Jr. Said

Jo Becker, Adam Goldman, and Matt Apuzzo
The New York Times, July 11, 2017

The June 3, 2016, email sent to Donald Trump Jr. could hardly have been more explicit: One of his father's former Russian business partners had been contacted by a senior Russian government official and was offering to provide the Trump campaign with dirt on Hillary Clinton.

The documents "would incriminate Hillary and her dealings with Russia and would be very useful to your father," read the email, written by a trusted intermediary, who added, "This is obviously very high level and sensitive information but is part of Russia and its government's support for Mr. Trump."

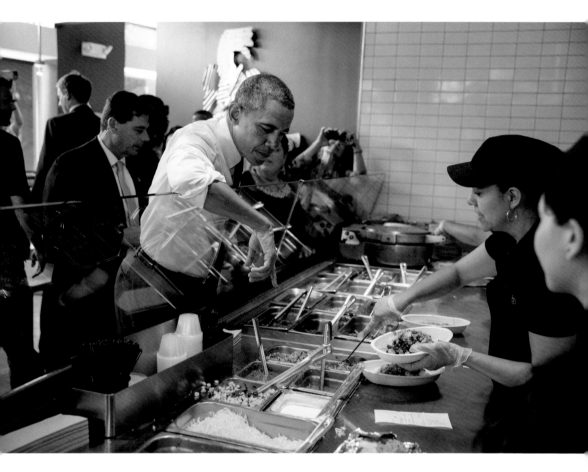

petesouza ✓ Remember this scandal from 2014? Just to get all the information out now: This was my fault, and I'm the only one to blame. If I hadn't posted this photograph, no one would have ever known he reached over the sneeze guard at Chipotle.

July 11, 2017

Trump Wants a "Transparent" Border Wall to Prevent Injuries from Falling "Sacks of Drugs"

Vanity Fair, July 13, 2017

QUESTION: You were joking about solar, right?

THE PRESIDENT: No, not joking, no. There is a chance we can do a solar wall…when they throw the large sacks of drugs over, and if you have people on the other side of the wall, you don't see them—they hit you on the head with 60 pounds of stuff? It's over…"

President Donald J. Trump
Q&A with reporters aboard *Air Force One,* July 13, 2017

petesouza ✓ Beware of flying objects. Viewing solar panels in Utah, 2015.

July 14, 2017

you remember that famous night on television, November 8th, where they said, these dis
ople, where they said, there is no path to victory for Donald Trump. They forgot about the for
ople. By the way, they're not forgetting about the forgotten people anymore. They're going
ng to figure it out, but I told them, far too late; it's far too late. But you remember that inc
ght with the maps, and the Republicans are red and the Democrats are blue, and that map v
d it was unbelievable. And they didn't know what to say. [APPLAUSE.] And you know, we h
mendous disadvantage in the electoral college. Popular vote is much easier. We have—be
w York, California, Illinois, you have to practically run the East Coast. And we did. We won F
e won South Carolina. We won North Carolina. We won Pennsylvania. [APPLAUSE.] **WE WON**
ON. SO WHEN THEY SAID, THERE IS NO WAY TO VICTORY; THERE IS NO WAY TO 27
ow I went to Maine four times because it's one vote, and we won. We won. One vote. I went
cause I kept hearing we're at 269. But then Wisconsin came in. Many, many years. Michigan ca
PPLAUSE.] So—and we worked hard there. You know, my opponent didn't work hard there, be
e was told…[BOOING.] She was told she was going to win Michigan, and I said, Well, wait a m
e car industry is moving to Mexico. Why is she going to move—she's there. Why are they allowir
ove? And by the way, do you see those car industry—do you see what's happening? They're c
ck to Michigan. They're coming back to Ohio. They're starting to peel back in. [APPLAUSE.] A
to Wisconsin, now, Wisconsin hadn't been won in many, many years by a Republican. But we
sconsin, and we had tremendous crowds. And I'd leave these massive crowds, I'd say, Why a
ing to lose this state? The polls, that's also fake news. They're fake polls. But the polls are saying
won Wisconsin. [APPLAUSE.] So I have to tell you, what we did, in all fairness, is an unbeli
oute to you and all of the other millions and millions of people that came out and voted for
herica great again. [Crowd: USA! USA! USA!] And I'll tell you what, we are indeed making Ar
eat again. What's going on is incredible. [APPLAUSE.] We had the best jobs report in 16 year
ock market on a daily basis is hitting an all-time high. We're going to be bringing back very soon t
dollars from companies that can't get their money back into this country, and that money is go
used to help rebuild America. We're doing things that nobody ever thought was possible, and
t started. It's just Scouts have sworn the same oath and lived according to the same law. You in

President Donald J. Trump
Remarks at the Boy Scout Jamboree, July 24, 2017

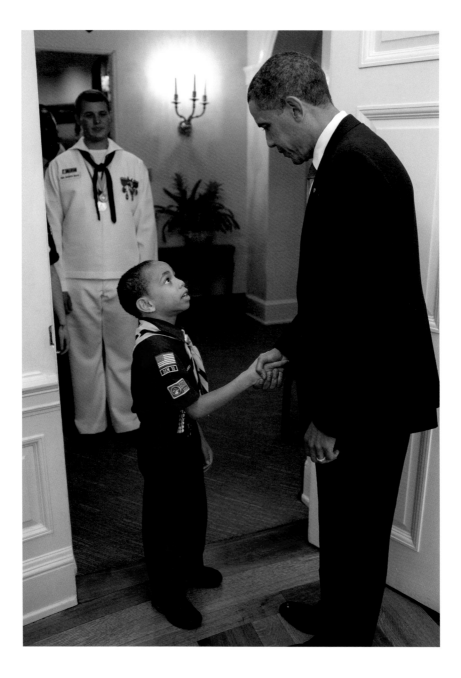

petesouza ✓ I can assure you, President Obama was not bragging to this Cub Scout, and the Boy Scouts who followed, about his electoral college victory.

July 24, 2017

Donald J. Trump ✔
@realDonaldTrump

Attorney General Jeff Sessions has taken a VERY weak position on Hillary Clinton crimes (where are E-mails & DNC server) & Intel leakers!

July 25, 2017 5:12 AM

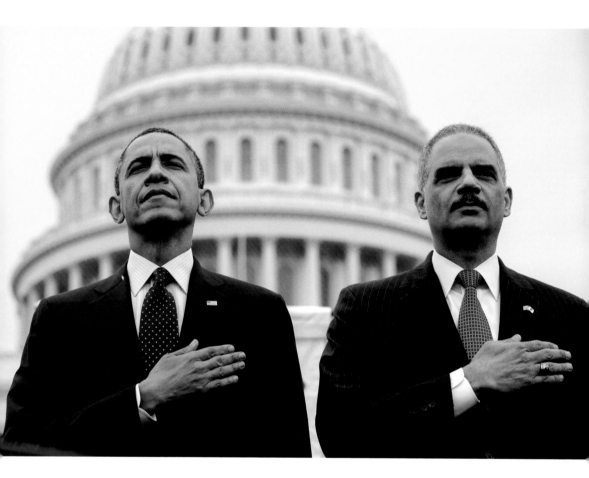

petesouza ✔ President Obama standing alongside Attorney General Eric Holder.

July 25, 2017

Donald J. Trump ✓
@realDonaldTrump

After consultation with my Generals and military experts, please be advised that the United States Government will not accept or allow......

July 26, 2017 7:55 AM

....Transgender individuals to serve in any capacity in the U.S. Military. Our military must be focused on decisive and overwhelming.....

July 26, 2017 8:04 AM

....victory and cannot be burdened with the tremendous medical costs and disruption that transgender in the military would entail. Thank you

July 26, 2017 8:08 AM

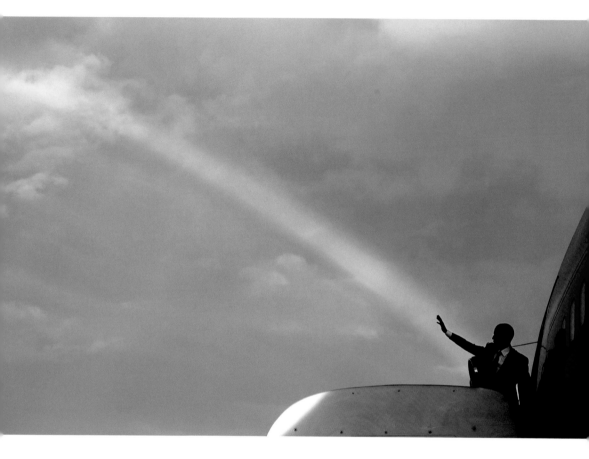

petesouza ● Departing Jamaica in 2015. In retrospect, maybe this photo symbolizes a time when the executive branch of our government didn't discriminate against our sisters and brothers in the LGBTQ community.

July 27, 2017

Trump Reportedly Calls White House "a Dump" to Justify His Many Golf Weekends

The Mercury News (San Jose), August 2, 2017

Donald J. Trump ✓
@realDonaldTrump

I love the White House, one of the most beautiful buildings (homes) I have ever seen. But Fake News said I called it a dump - TOTALLY UNTRUE

August 2, 2017 8:29 PM

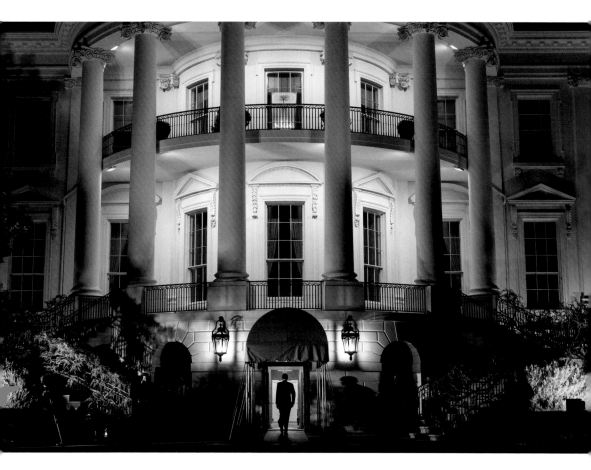

petesouza ✔ Despite what some say, the White House is definitely not "a dump." What a shameful thing to say, or even think. It belittles the honorable men and women who make the White House the exemplary historical place it is, opening its doors to thousands of people every day.

August 1, 2017

Trump Is Criticized for Not Calling Out White Supremacists

Glenn Thrush and Maggie Haberman
The New York Times, August 12, 2017

BRIDGEWATER, N.J.—President Trump is rarely reluctant to express his opinion, but he is often seized by caution when addressing the violence and vitriol of white nationalists, neo-Nazis and alt-right activists, some of whom are his supporters…

During a brief and uncomfortable address to reporters at his golf resort in Bedminster, N.J., he called for an end to the violence. But he was the only national political figure to spread blame for the "hatred, bigotry and violence" that resulted in the death of one person to "many sides."

…like several other statements Mr. Trump made on Saturday, the tweet made no mention that the violence in Charlottesville was initiated by white supremacists brandishing anti-Semitic placards, Confederate battle flags, torches and a few Trump campaign signs.

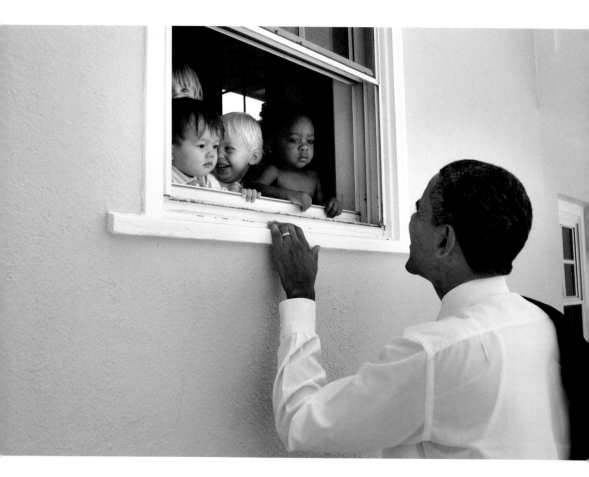

petesouza ✓ So glad that my former boss used this photograph on Twitter and quoted Nelson Mandela to comment on the awful events today in Charlottesville. "No one is born hating another person because of the color of his skin or his background or his religion. People must learn to hate, and if they can learn to hate, they can be taught to love. For love comes more naturally to the human heart than its opposite." —Nelson Mandela

August 12, 2017

QUESTION: You said there was hatred, there was violence on both sides. Are the—

THE PRESIDENT: Yes, I think there's blame on both sides. If you look at both sides—I think there's blame on both sides. And I have no doubt about it, and you don't have any doubt about it either. And if you reported it accurately, you would say.

QUESTION: The neo-Nazis started this. They showed up in Charlottesville to protest—

THE PRESIDENT: Excuse me, excuse me. They didn't put themselves—and you had some very bad people in that group, but you also had people that were very fine people, on both sides.

President Donald J. Trump
Transcript from a press conference at Trump Tower about Charlottesville,
August 15, 2017

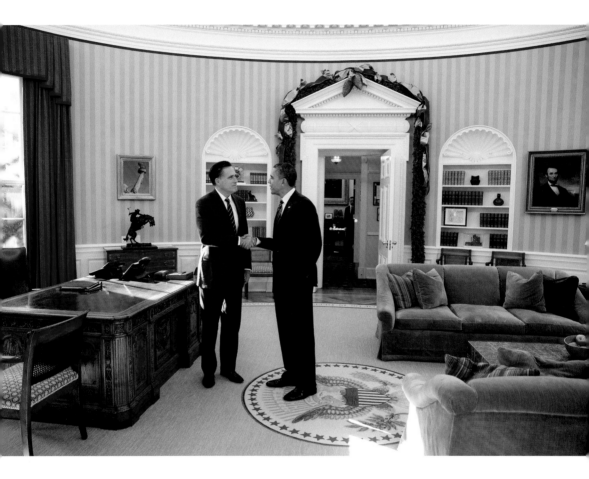

petesouza ☑ Mitt Romney spoke out today about the violence in Charlottesville. "No, not the same," he tweeted. "One side is racist, bigoted, Nazi. The other opposes racism and bigotry. Morally different universes."

August 15, 2017

Trump Has Failed to Offer Moral Leadership After Charlottesville

James Hohmann
The Washington Post, August 17, 2017

It's not enumerated in Article Two of the Constitution, but consoler in chief has always been one of the most important responsibilities of the American president. Playing this part has only become more important in the television age, and Donald Trump—who became president partially because of his mastery of the reality TV medium—has utterly failed to offer moral leadership during the biggest test yet of his seven-month presidency.

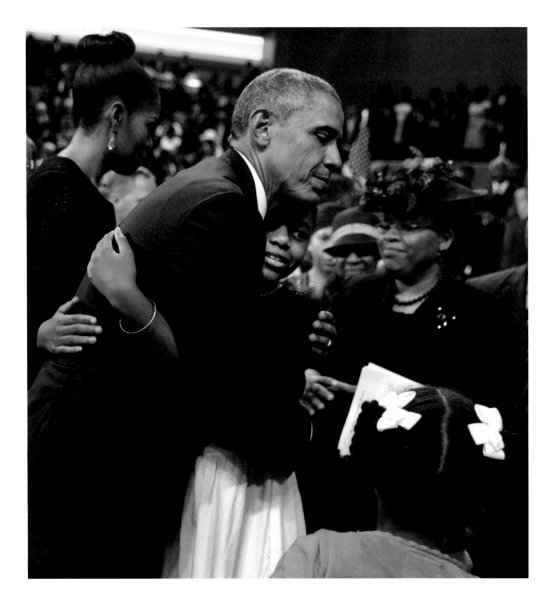

petesouza ✔ Greeting family members of Reverend Clementa Pinckney at the conclusion of his funeral service in Charleston, S.C. Reverend Pinckney was killed in a mass shooting and hate crime in which a white supremacist murdered nine African Americans during a prayer service at Emanuel African Methodist Episcopal Church.

August 17, 2017

"…But the very dishonest media, those people right up there with all the cameras."

[BOOING.]

"So the—and I mean truly dishonest people in the media and the fake media, they make up stories. They have no sources in many cases. They say 'a source says'—there is no such thing. But they don't report the facts…"

President Donald J. Trump
Transcript of speech at rally for supporters in Phoenix, Arizona, August 23, 2017

petesouza ✔ How a President normally engages with the press.
(Or is it: How a normal President engages with the press.) ▶

August 23, 2017

Trump Ends DACA Program, No New Applications Accepted

Adam Edelman
NBC News, September 5, 2017

The Justice Department announced on Tuesday it is ending DACA, the Obama-era program that allowed undocumented immigrants who came to the U.S. as children to remain in the country, while also giving Congress a six-month window to possibly save the policy.

Donald J. Trump ✔
@realDonaldTrump

Congress now has 6 months to legalize DACA (something the Obama Administration was unable to do). If they can't, I will revisit this issue!

September 5, 2017 7:38 PM

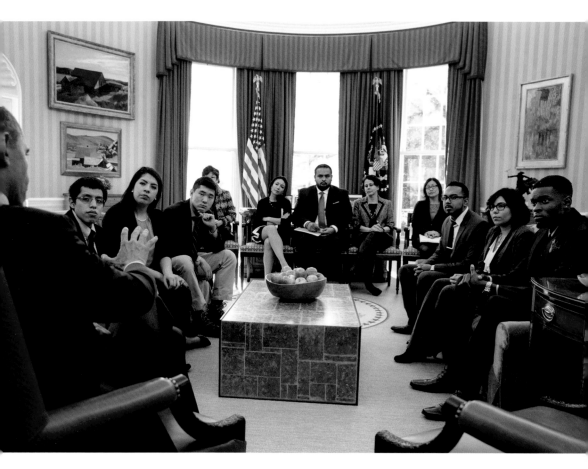

petesouza ✔ President Obama meeting with undocumented immigrants who were brought to the United States as young kids and raised as Americans. Under the Deferred Action for Childhood Arrivals program—DACA—800,000 young people have been allowed to receive two-year work permits and are protected from deportation. Recipients have to undergo a background check and certify they have not been convicted of any crimes.

September 5, 2017

Donald J. Trump ✔
@realDonaldTrump

I spoke with President Moon of South Korea last night.
Asked him how Rocket Man is doing. Long gas lines
forming in North Korea. Too bad!

September 17, 2017 6:53 AM

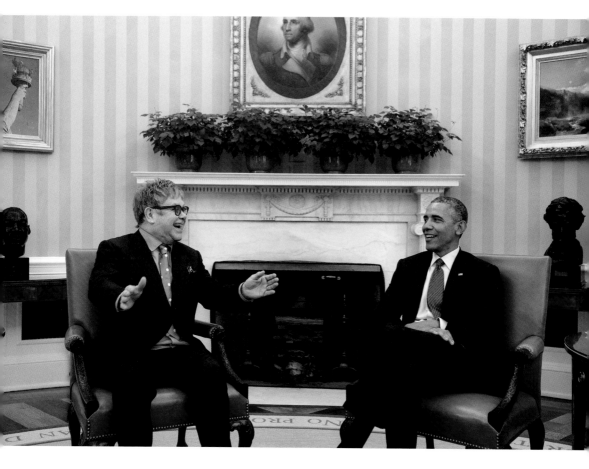

petesouza ✔ There's only one Rocket Man—Sir Elton John.

September 17, 2017

Trump Administration Projects Confidence Amid Puerto Rico Crisis

Jeremy Diamond
CNN, September 28, 2017

WASHINGTON—The White House projected confidence Thursday in its response to Puerto Rico, even as pictures of the devastation—impassable roads and long lines for fuel, water and food—continued to play out on TV screens across the country.

Eight days after Hurricane Maria made landfall, nearly half the population still does not have access to potable water and huge numbers of people are struggling to get access to fuel to power generators, according to the Federal Emergency Management Agency. Nearly the entire island remains in the dark after the power grid was knocked offline.

Donald J. Trump ✓
@realDonaldTrump

Such poor leadership ability by the Mayor of San Juan, and others in Puerto Rico, who are not able to get their workers to help.

September 30, 2017 6:26 AM

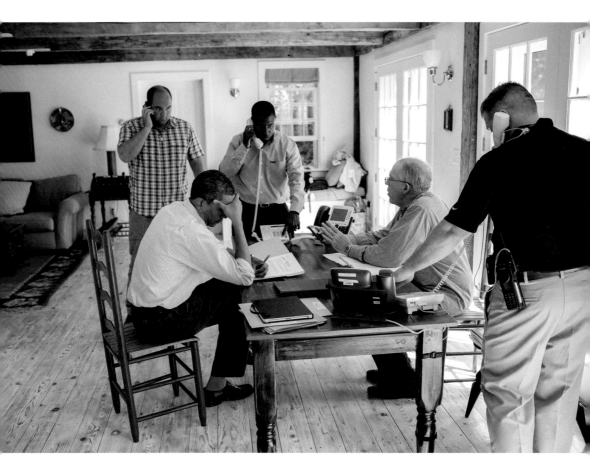

petesouza ✓ While on vacation on Martha's Vineyard in 2011, President Obama, with Homeland Security Advisor John Brennan and others, waits to start a conference call with mayors and governors affected by Hurricane Irene. The President cut short his vacation to monitor the situation from Washington as the Category 2 storm moved its way up the Eastern Seaboard.

September 30, 2017

HANNITY: Hey, come on. Help me out here.

[CHEERS.]

TRUMP: I will say this: you have been so great. I'm very proud of you. I am a ratings person. Has anyone seen his ratings? What you are doing to your competition is incredible. Number one, and I am very proud of you. An honor to be on your show.

President Donald J. Trump with Sean Hannity
Fox News, October 11, 2017

petesouza ● Six years ago today: riding in the motorcade to the airport in Pittsburgh. I was reminded every day that his was a serious job. And every day, he took his job seriously.

October 11, 2017

"Disrespectful Lie": Anger Grows over Trump's Claims About Past Presidents and Fallen Troops

The Washington Post, October 17, 2017

"If you look at President Obama and other presidents, most of them didn't make calls. A lot of them didn't make calls. I like to call when it's appropriate, when I think I am able to do it."

President Donald J. Trump
Remarks in the White House Rose Garden, October 17, 2017

Donald J. Trump ✓
@realDonaldTrump

Democrat Congresswoman totally fabricated what I said to the wife of a soldier who died in action (and I have proof). Sad!

October 18, 2017 6:25 AM

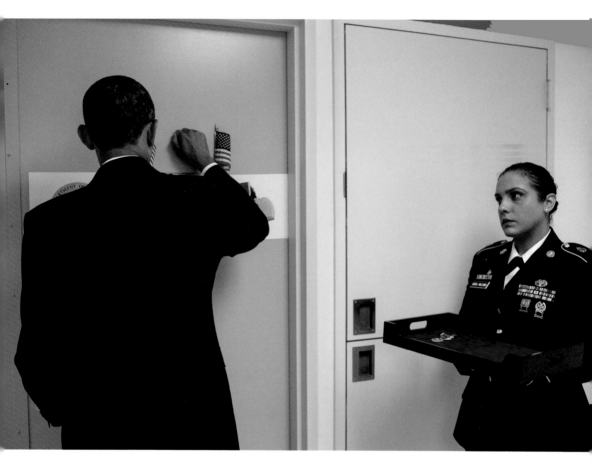

petesouza ⊘ I accompanied President Obama every time he visited with wounded warriors and their loved ones at Walter Reed National Military Medical Center. Here, he knocks on the door of a wounded warrior at Walter Reed before presenting him with a Purple Heart citation.

October 18, 2017

Donald J. Trump ✔
@realDonaldTrump

The meeting with Republican Senators yesterday, outside of Flake and Corker, was a love fest with standing ovations and great ideas for USA!

October 25, 2017 6:30 AM

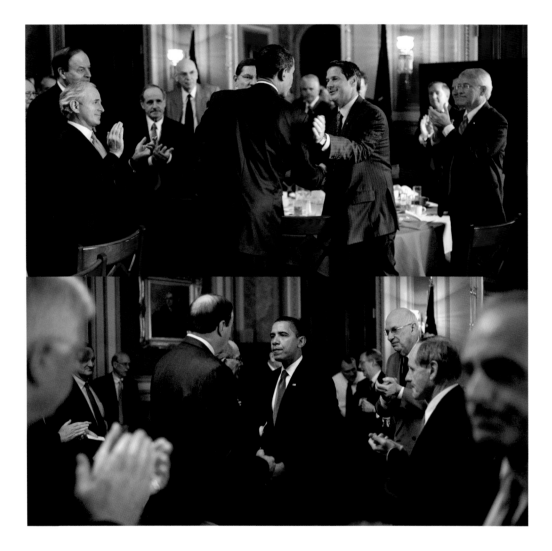

petesouza ✔ President Obama at a Senate Republican Caucus meeting at the U.S. Capitol during the first year of his Presidency. Looks like they're all standing.

October 25, 2017

Trump Greets Kids in Oval Office for Early Halloween Treats

Associated Press, October 27, 2017

"You have no weight problems, that's the good news, right?" he said at one point. "So you take out whatever you need, OK? If you want some for your friends, take 'em. We have plenty."

Trump Had an Incredibly Awkward Encounter with a Kid Dressed as a Dinosaur at the White House

Erica Gonzales
Harper's Bazaar, October 31, 2017

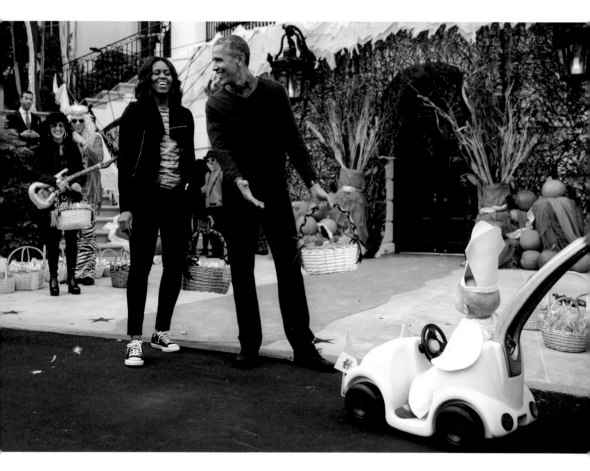

petesouza ✓ Remembering that time a little popemobile stopped by for Halloween trick-or-treating.

October 27, 2017

Donald J. Trump ✓
@realDonaldTrump

Does the Fake News Media remember when Crooked Hillary Clinton, as Secretary of State, was begging Russia to be our friend with the misspelled reset button? Obama tried also, but he had zero chemistry with Putin.

November 11, 2017 7:43 PM

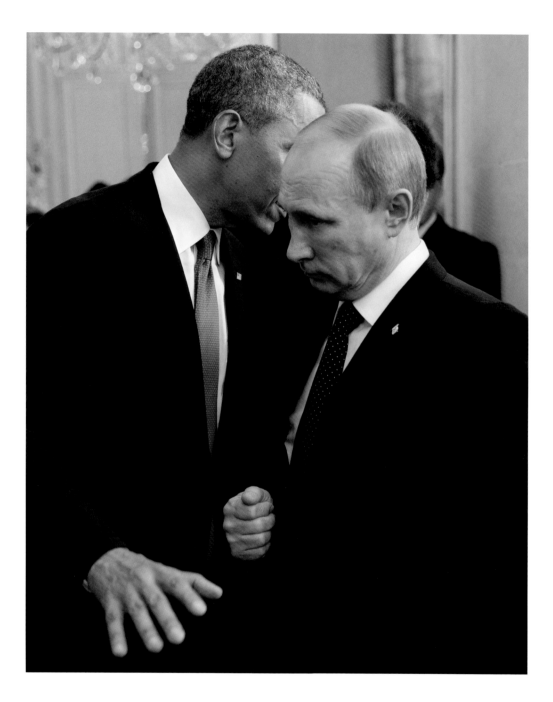

petesouza ✔ *"Zero chemistry."*

November 12, 2017

Donald Trump Paused His Speech to Drink Water for What Felt Like an Eternity

Nicholas Hautman
Us Weekly, November 16, 2017

President Donald Trump was very thirsty on Wednesday, November 15. Ten minutes into his speech at the White House, he abruptly paused to take an extended drink of water.

While recapping his recent 11-day, five-nation Asia trip, the parched 71-year-old bent over to look behind his podium for something to quench his thirst. "They don't have water. That's OK," he said. A reporter then pointed to a bottle of Fiji water within arm's reach of the lectern, saying, "To your right, sir."

Trump grabbed the bottle and turned to the side as he spent six seconds unscrewing the cap. He then gripped the bottle with both hands, chucked his head back, and took a gulp. The reporters in the room stayed silent throughout the entire debacle.

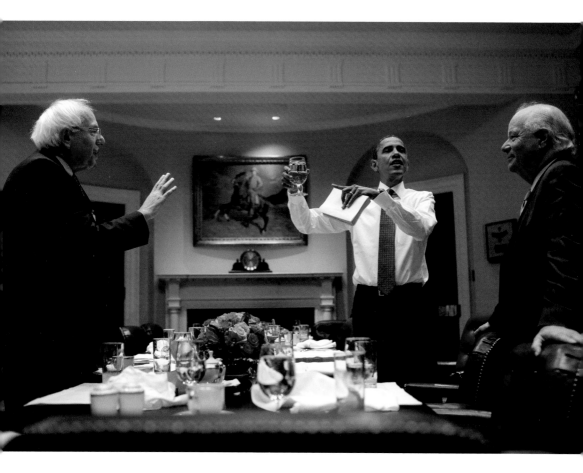

petesouza ✓ One-handed.

November 16, 2017

Donald J. Trump ✔
@realDonaldTrump

@FoxNews is MUCH more important in the United States
than CNN, but outside of the U.S., CNN International
is still a major source of (Fake) news, and they represent
our Nation to the WORLD very poorly. The outside
world does not see the truth from them!

November 25, 2017 5:37 PM

Donald J. Trump ✔
@realDonaldTrump

We should have a contest as to which of the Networks,
plus CNN and not including Fox, is the most dishonest,
corrupt and/or distorted in its political coverage of your
favorite President (me). They are all bad. Winner to
receive the FAKE NEWS TROPHY!

November 27, 2017 9:04 AM

Donald J. Trump ✔
@realDonaldTrump

Another false story, this time in the Failing @nytimes, that I
watch 4-8 hours of television a day - Wrong! Also, I seldom,
if ever, watch CNN or MSNBC, both of which I consider
Fake News. I never watch Don Lemon, who I once called
the "dumbest man on television!" Bad Reporting.

December 11, 2017 9:17 AM

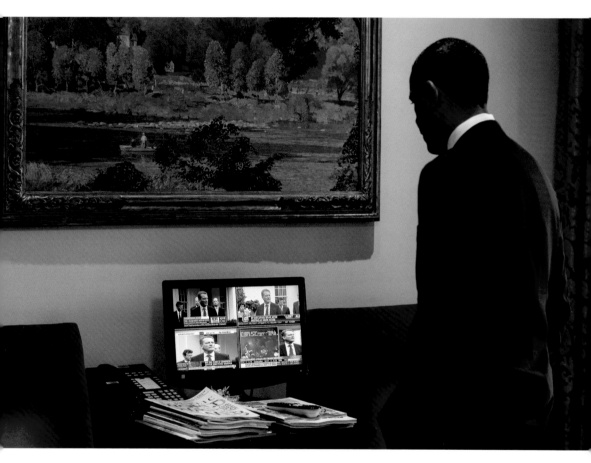

petesouza ✔ One of the pillars of our democracy is freedom of the press. Which includes television news. Be wary of people who denigrate our First Amendment.

November 26, 2017

Donald J. Trump ✓
@realDonaldTrump

I had to fire General Flynn because he lied to the Vice President and the FBI. He has pled guilty to those lies. It is a shame because his actions during the transition were lawful. There was nothing to hide!

December 2, 2017 12:14 PM

petesouza ✔ Peek-a-boo.

December 2, 2017

Donald J. Trump ✔
@realDonaldTrump

The Tax Cuts are so large and so meaningful, and yet the Fake News is working overtime to follow the lead of their friends, the defeated Dems, and only demean. This is truly a case where the results will speak for themselves, starting very soon...

December 20, 2017 9:32 AM

Trump Just Admitted the GOP's Tax Cuts Were Deceptively Sold

Aaron Blake
The Washington Post, December 20, 2017

President Trump was so excited about passing his first major piece of legislation Wednesday that he blurted out that the Republican Party had misrepresented the entire bill, handing Democrats some potentially troublesome talking points for the 2018 midterm elections.

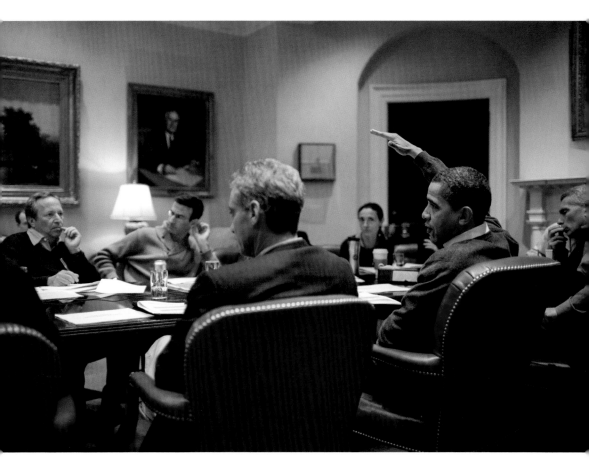

petesouza ✔ Saturday, January 24, 2009. During weekend meetings like this, President Obama met with his economic team to make the decisions that helped get our country out of the greatest financial crisis since the Great Depression. What matters with economic policies are the long-term implications. The decisions the Obama administration made in 2009 and 2010 helped move the economy in the right direction today. Wonder how things will look in four to five years after today's vote?

December 20, 2017

Donald J. Trump ✓
@realDonaldTrump

North Korean Leader Kim Jong Un just stated that the "Nuclear Button is on his desk at all times." Will someone from his depleted and food starved regime please inform him that I too have a Nuclear Button, but it is a much bigger & more powerful one than his, and my Button works!

January 2, 2018 4:49 PM

petesouza ✔ And fortunately the red button on the Resolute Desk is to call for the Oval Office valet, not to start a war.

January 2, 2018

Donald J. Trump ✓
@realDonaldTrump

....Actually, throughout my life, my two greatest assets have been mental stability and being, like, really smart. Crooked Hillary Clinton also played these cards very hard and, as everyone knows, went down in flames. I went from VERY successful businessman, to top T.V. Star.....

January 6, 2018 8:27 AM

petesouza ✓ Two, like, really smart Presidents... ▶

January 6, 2018

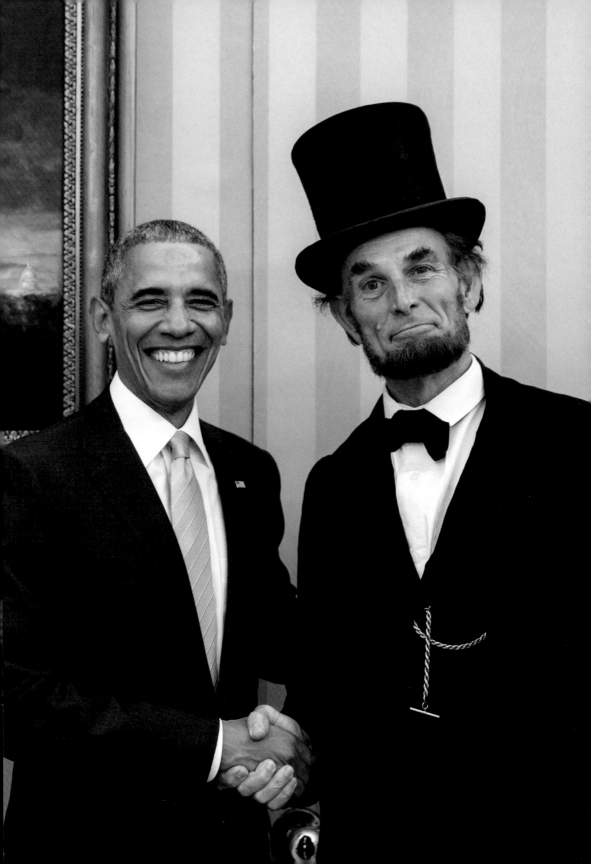

Donald J. Trump ✓
@realDonaldTrump

....to President of the United States (on my first try).
I think that would qualify as not smart, but genius....
and a very stable genius at that!

January 6, 2018 8:30 AM

petesouza ✓ Heading to the stable (noun, 1: a building for the lodging and feeding of horses, etc.).

January 6, 2018

Donald Trump Appears to Have Forgotten the Words to Our National Anthem

Marie Claire, January 8, 2018

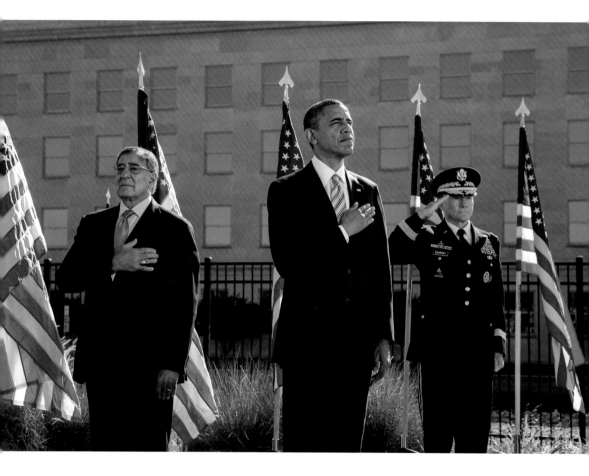

petesouza ✔ Yes, they all knew the words.

January 8, 2018

Trump Derides Protections for Immigrants from "Shithole" Countries

Josh Dawsey
The Washington Post, January 11, 2018

President Trump grew frustrated with lawmakers
Thursday in the Oval Office when they
discussed protecting immigrants from Haiti,
El Salvador and African countries as part
of a bipartisan immigration deal, according to
several people briefed on the meeting.

"Why are we having all these people from shithole
countries come here?" Trump said, according
to these people, referring to countries mentioned
by the lawmakers.

THE OBAMA WHITE HOUSE

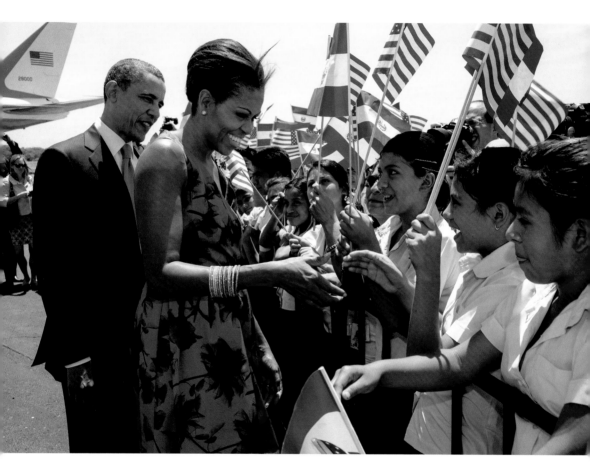

petesouza ✔ Greeting youngsters in San Salvador in 2011. I thought El Salvador was a great country and definitely not a "shithole."

January 11, 2018

Jay-Z Slams Trump's "Shithole" Comment as "Hurtful"

Melissa Mahtani
CNN, January 28, 2018

Hip-hop legend Shawn "Jay-Z" Carter described President Donald Trump's "shithole countries" comment as disappointing and hurtful.

"Everyone feels anger, but after the anger it's really hurtful because he's looking down on a whole population of people and he's so misinformed because these places have beautiful people," he told Van Jones on the debut of his CNN program, "The Van Jones Show," which aired Saturday on CNN.

Donald J. Trump ✓
@realDonaldTrump

Somebody please inform Jay-Z that because of my policies, Black Unemployment has just been reported to be at the LOWEST RATE EVER RECORDED!

January 28, 2018 8:18 AM

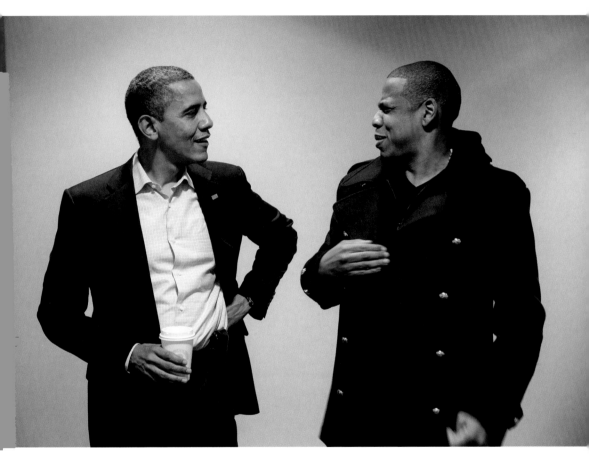

petesouza ✅ WTF?

January 28, 2018

Donald J. Trump ✓
@realDonaldTrump

Thank you for all of the nice compliments and reviews
on the State of the Union speech. 45.6 million
people watched, the highest number in history.
@FoxNews beat every other Network...

February 1, 2018 7:02 AM

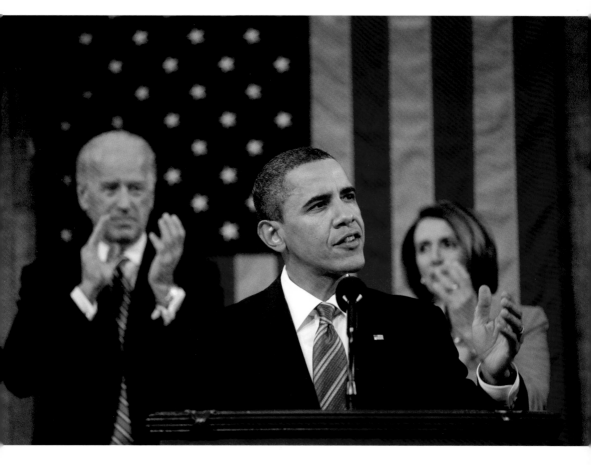

petesouza ✓ 48 million people watched the 2010 State of the Union address
on television. Just saying.

February 1, 2018

Trump on Florida Shooting: "I'd Run in There Even if I Didn't Have a Weapon"

Cristiano Lima
Politico, February 26, 2018

President Donald Trump on Monday criticized the sheriff's deputies who reportedly failed to intervene during the deadly school shooting in Parkland, Florida, saying he would have "run in there" to help if he had been there.

"I really believe I'd run in there even if I didn't have a weapon," Trump said during a White House meeting with governors to discuss school safety.

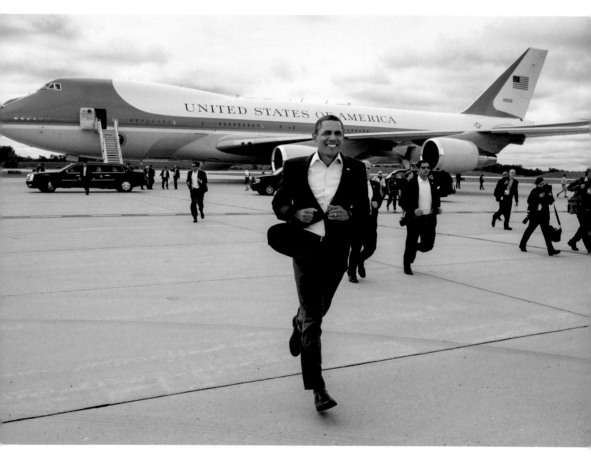

petesouza ✅ Back in the day when our President could run.

February 26, 2018

Donald J. Trump ✓
@realDonaldTrump

WITCH HUNT!

February 27, 2018 7:49 AM

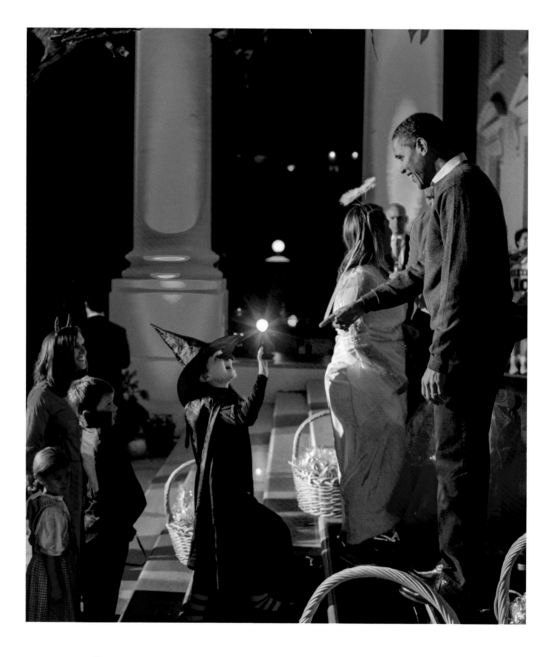

petesouza ✔ A different kind of witch hunt (Halloween 2010).

February 27, 2018

Donald J. Trump ✓
@realDonaldTrump

The new Fake News narrative is that there is CHAOS in the White House. Wrong! People will always come & go, and I want strong dialogue before making a final decision. I still have some people that I want to change (always seeking perfection). There is no Chaos, only great Energy!

March 6, 2018 7:55 AM

petesouza � Chaos in the Obama White House! Ben Rhodes needing help with a new shirt. Left to right: Brian Mosteller, Ferial Govashiri, Rhodes, and some guy with the collar stays.

March 7, 2018

Tensions Escalate After Tillerson Calls Trump "Moron"

CNN, October 5, 2017

Trump Humiliates Rex Tillerson for the Last Time

The Washington Post, March 13, 2018

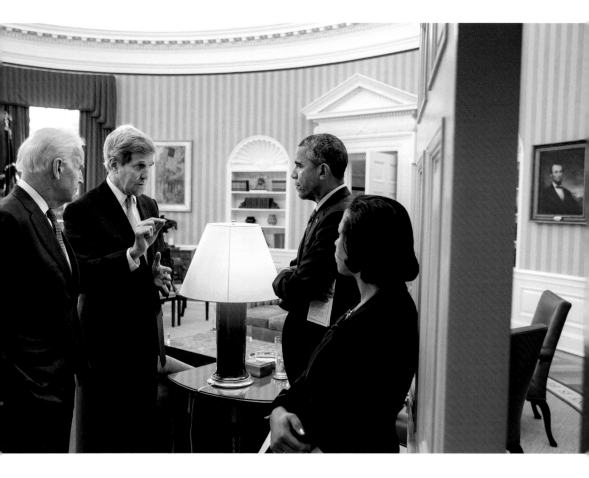

petesouza ✖ When our Secretary of State was treated with respect, and vice versa.

March 13, 2018

Donald J. Trump ✓
@realDonaldTrump

Andrew McCabe FIRED, a great day for the hard working men and women of the FBI - A great day for Democracy. Sanctimonious James Comey was his boss and made McCabe look like a choirboy. He knew all about the lies and corruption going on at the highest levels of the FBI!

March 16, 2018 11:08 PM

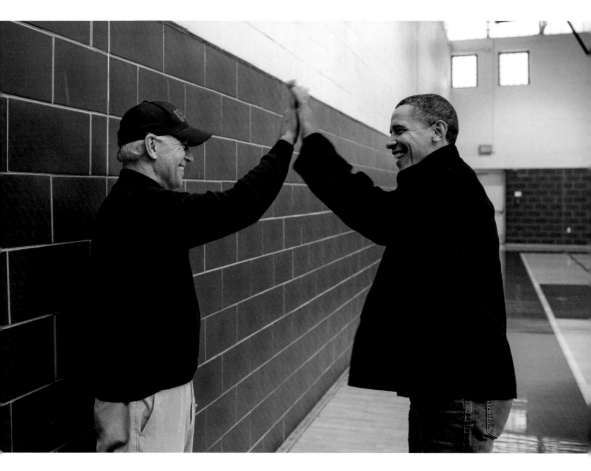

petesouza ✔ Why are they high-fiving? Definitely not because they just fired a career public servant two days before his retirement.

March 17, 2018

Joe Biden Said He Would "Beat the Hell" Out of President Trump for Disrespecting Women

He spoke Tuesday at an anti-sexual assault rally at the University of Miami.

The Boston Globe, March 21, 2018

"A guy who ended up becoming our national leader said, 'I can grab a woman anywhere and she likes it,'" Biden says. "If we were in high school, I'd take him behind the gym and beat the hell out of him."

Biden says any guy who disrespected women was "usually the fattest, ugliest S.O.B. in the room."

Donald J. Trump ✔
@realDonaldTrump

Crazy Joe Biden is trying to act like a tough guy. Actually, he is weak, both mentally and physically, and yet he threatens me, for the second time, with physical assault. He doesn't know me, but he would go down fast and hard, crying all the way. Don't threaten people Joe!

March 22, 2018 5:19 AM

petesouza ✔ "Wait until he sees the Biden shuffle. First, I'll tire him out, then BOOM, I'll excoriate him with a one, two." ▶

March 22, 2018

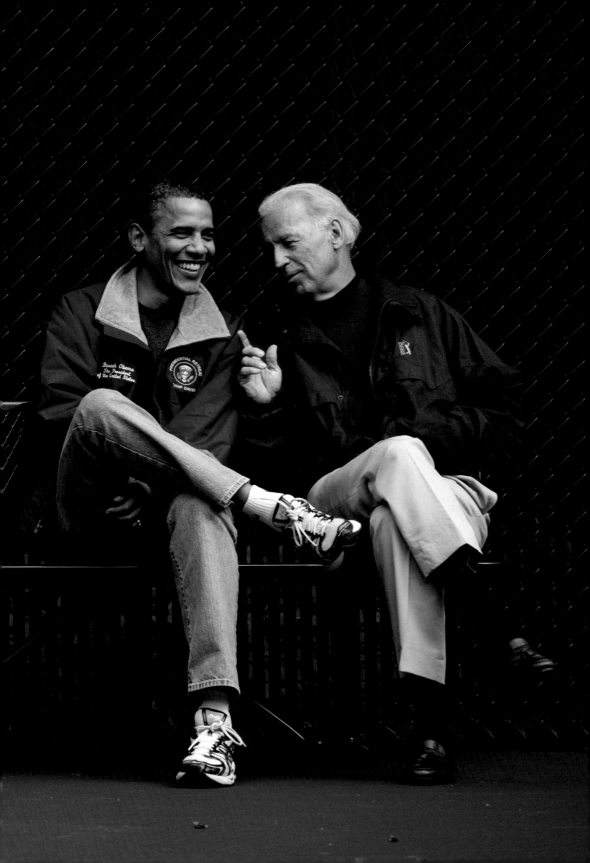

March for Our Lives: Hundreds of Thousands Demand End to Gun Violence

Oliver Laughland and Lois Beckett
The Guardian, March 24, 2018

Hundreds of thousands of people have gathered in Washington to call for tighter gun laws following the massacre at a high school in Parkland, Florida, last month.

The rally was led by young activists from Parkland and across the country, in an array of powerful and composed speeches from young people from diverse backgrounds.

The White House praised the demonstrators for exercising their right to free speech, but Donald Trump himself was silent at the time of writing, seeming to spend much of the day at his golf club in Florida.

Barack Obama tweeted: "Michelle and I are so inspired by all the young people who made today's marches happen. Keep at it. You're leading us forward."

petesouza ✅ President Obama signs letters from children backstage after issuing executive orders and unveiling new gun control proposals on January 16, 2013.

March 24, 2018

Hired and Fired: The Unprecedented Turnover of the Trump Administration

The New York Times, March 16, 2018

Trump Embraces His Impulses in Ever-Chaotic Oval Office

Pamela Brown and Kevin Liptak
CNN, April 3, 2018

As he continues to shed advisers he's deemed insufficiently aligned with his agenda, he's ignored the advice of his senior-most aides to try and mitigate the appearance of disarray. Instead, he's heightened the sense that his administration is lurching from one firing to the next by dispatching tweets announcing his decisions as they happen, and discarding advice to formalize his personnel announcements.

petesouza ✔ Apparently the Easter Bunny just got axed; no one even noticed.

April 3, 2018

"Also, I want to thank the White House Historical Association and all of the people that work so hard with Melania, with everybody, to keep this incredible house or building, or whatever you want to call it—because there really is no name for it; it is special—and we keep it in tip-top shape. We call it sometimes tippy-top shape. And it's a great, great place."

President Donald J. Trump
Remarks at the White House Easter Egg Roll, April 2, 2018

petesouza ✓ It's called the White House. And the reason it's in "tippy-top" shape is because of the permanent White House staff.

April 3, 2018

Trump Mocks
Martin Luther King's Dream

Colbert I. King
The Washington Post, April 4, 2018

Five decades after King's assassination, America has
the whitest White House and the most racially exclusive
cadre of presidential appointees since the presidency
of Herbert Hoover. The composition of Donald Trump's
administration mocks the White House's claim to govern
under an "American spirit of fraternity."

petesouza ✔ Stevie Wonder feels the bust of Martin Luther King Jr. in 2016.

April 4, 2018

"When You Lose that Power": How John Kelly Faded as White House Disciplinarian

Ashley Parker, Josh Dawsey, and Philip Rucker
The Washington Post, April 7, 2018

The recurring and escalating clashes between the president and his chief of staff trace the downward arc of Kelly's eight months in the White House. Both his credibility and his influence have been severely diminished, administration officials said, a clear decline for the retired four-star Marine Corps general who arrived with a reputation for integrity and a mandate to bring order to a chaotic West Wing…

This portrait of Kelly's trajectory is based on interviews with 16 administration officials, outside advisers and presidential confidants, many of whom spoke on the condition of anonymity to assess the chief of staff.

Donald J. Trump ✔
@realDonaldTrump

The Washington Post is far more fiction than fact. Story after story is made up garbage - more like a poorly written novel than good reporting. Always quoting sources (not names), many of which don't exist. Story on John Kelly isn't true, just another hit job!

April 8, 2018 6:58 AM

petesouza ✔ Back when we had a President who read a newspaper and didn't call it fake news even when he was criticized.

April 8, 2018

Donald J. Trump ✓
@realDonaldTrump

Russia vows to shoot down any and all missiles fired at Syria. Get ready Russia, because they will be coming, nice and new and "smart!" You shouldn't be partners with a Gas Killing Animal who kills his people and enjoys it!

April 11, 2018 5:57 AM

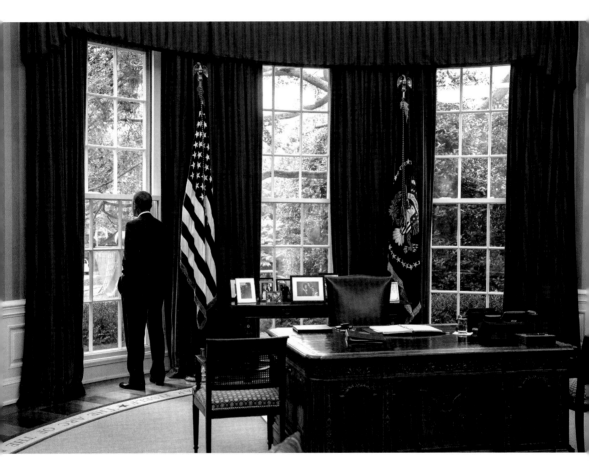

petesouza ✔ President Obama in 2013 as he waited for a phone call with one of our allies to discuss the situation in Syria. He certainly never sent out an impulsive tweet about a serious national security crisis.

April 11, 2018

Donald J. Trump ✓
@realDonaldTrump

A perfectly executed strike last night. Thank you to France and the United Kingdom for their wisdom and the power of their fine Military. Could not have had a better result. Mission Accomplished!

April 14, 2018 7:21 AM

Trump Mocked for "Mission Accomplished!" Tweet

CNN, April 14, 2018

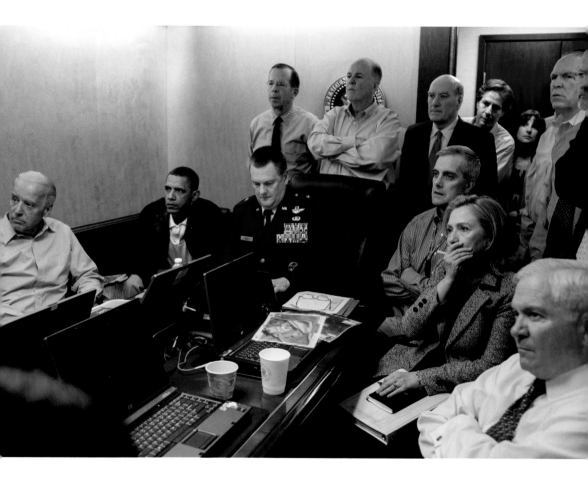

petesouza ✓ Back when a mission was actually accomplished.

April 14, 2018

In a Private Dinner,
Trump Demanded Loyalty.
Comey Demurred.

The New York Times, May 11, 2018

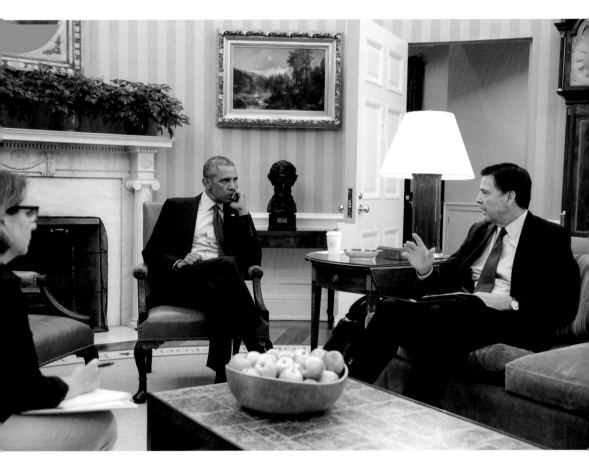

petesouza ✓ A loyalty pledge was neither needed nor asked for.

April 15, 2018

Donald J. Trump ✓
@realDonaldTrump

So exciting! I have agreed to be the Commencement
Speaker at our GREAT Naval Academy on May 25th in
Annapolis, Maryland. Looking forward to being there.

April 20, 2018 5:43 AM

petesouza ✔ President Obama at the Naval Academy commencement in 2013. The President of the United States is always invited, on a rotating basis, to one of the military service academies' commencements. President Obama always refrained from making a political speech at these events.

April 20, 2018

Donald J. Trump ✔
@realDonaldTrump

The New York Times and a third rate reporter named Maggie Habberman, known as a Crooked H flunkie who I don't speak to and have nothing to do with, are going out of their way to destroy Michael Cohen and his relationship with me in the hope that he will "flip."

April 21, 2018 7:17 AM

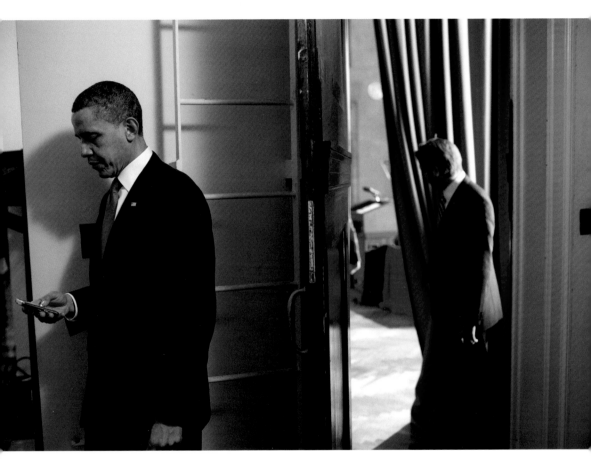

petesouza ✔ Pretty sure he wasn't slandering someone on Twitter.

April 21, 2018

"Maybe I didn't get her so much. I got her a beautiful
card. You know I'm very busy to be running
out looking for presents…"

President Donald J. Trump
Interview with *Fox & Friends* on his wife's birthday, April 26, 2018

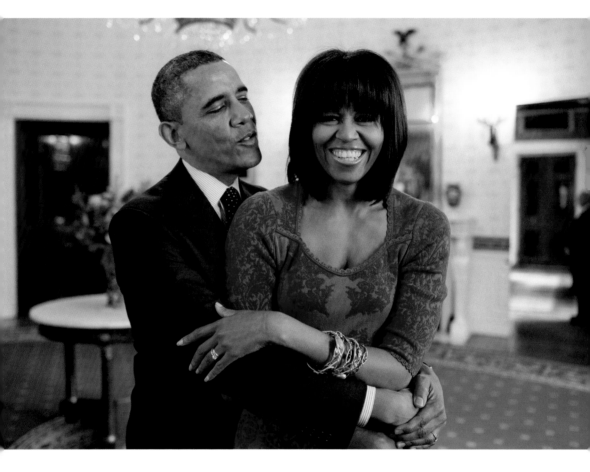

petesouza ✔ Singing "Happy Birthday" to the First Lady in 2013. He always gave her a present, too.

April 26, 2018

Trump Assails White House Correspondents' Association amid Michelle Wolf Controversy

Brian Stelter
CNN, April 30, 2018

WASHINGTON—The White House Correspondents' Association is the newest front in President Donald Trump's long-running war with the media.

The President continued to slam the organization and its annual dinner on Monday morning, tweeting that the event is "DEAD as we know it. This was a total disaster and an embarrassment to our great Country and all that it stands for. FAKE NEWS is alive and well and beautifully represented on Saturday night!"

On Sunday, he called comedian Michelle Wolf—who ripped into Trump and his aides on national television— "filthy" and suggested that the organization "put Dinner to rest, or start over!"

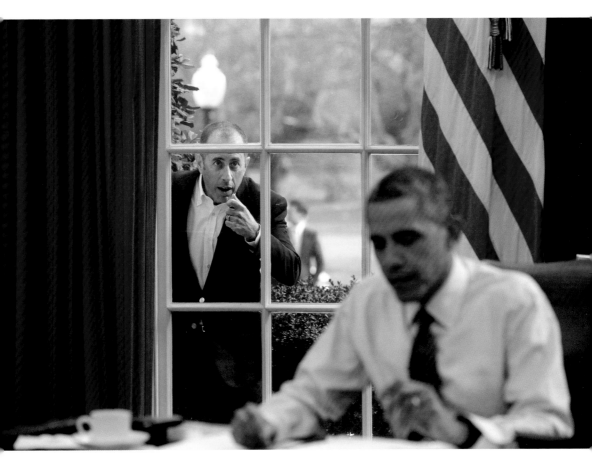

petesouza ✓ Back in the day when a comedian was a welcome intrusion in Washington.

May 2, 2018

Donald Trump Repaid His Lawyer for Stormy Daniels Hush Money, Says Rudy Giuliani

Ed Pilkington
The Guardian, May 3, 2018

Donald Trump personally repaid his lawyer Michael Cohen the $130,000 hush money given to the adult-film star Stormy Daniels days before the 2016 presidential election to buy her silence over an alleged affair, Rudy Giuliani said on Wednesday night...

"So they funneled it through the law firm," Hannity [Sean Hannity of Fox News, during his interview with Trump attorney Rudy Giuliani] asked, referring to Cohen's legal practice.

"Funneled it through the law firm," Giuliani concurred, "and the president repaid it."

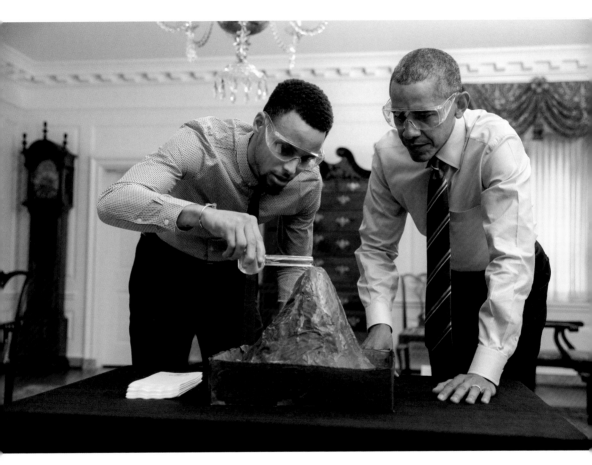

petesouza ✔ When the word "funneled" was used during science experiments, not questionable financial transfers concerning a porn star.

May 3, 2018

Porn Star Stormy Daniels' Lawyer Says She Had Affair with Donald Trump

Time, March 7, 2018

Payment to Stormy Daniels May Have Broken Campaign Finance Law

NPR, March 25, 2018

Trump Says He Didn't Know About Stormy Daniels Payment

CNN, April 6, 2018

Giuliani Says Trump Repaid Cohen for Stormy Daniels Hush Money

The New York Times, May 2, 2018

Trump Says Payment to Stormy Daniels Did Not Violate Campaign Laws

The New York Times, May 3, 2018

Trump Form Discloses Debt Payment to Cohen, Lawyer Who Paid Stormy Daniels

NBC News, May 16, 2018

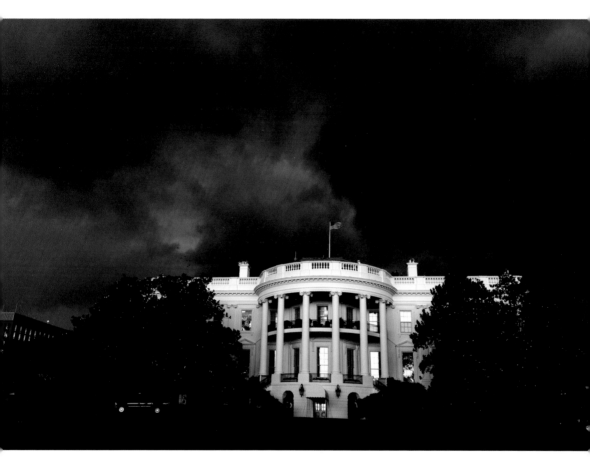

petesouza ✔ Stormy.

May 6, 2018

Trump Abandons Iran Nuclear Deal He Long Scorned

Mark Landler
The New York Times, May 8, 2018

President Trump declared on Tuesday that he was withdrawing from the Iran nuclear deal, unraveling the signature foreign policy achievement of his predecessor Barack Obama, isolating the United States from its Western allies and sowing uncertainty before a risky nuclear negotiation with North Korea.

The decision, while long anticipated and widely telegraphed, leaves the 2015 agreement reached by seven countries after more than two years of grueling negotiations in tatters.

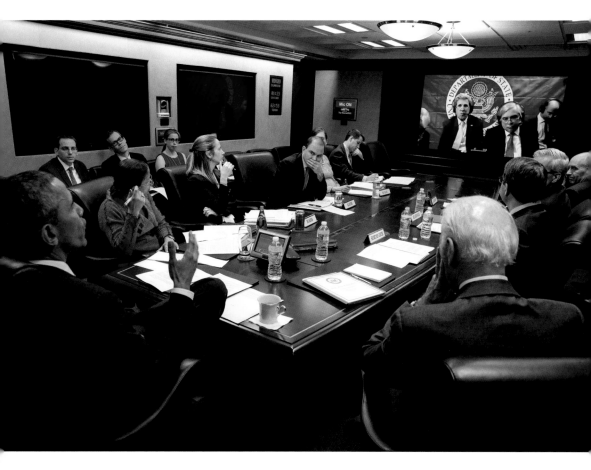

petesouza ✔ I trust this negotiation team—with a nuclear physicist—more than someone who reacts out of spite.

May 8, 2018

Gathering of Military Spouses Puts the "White" in White House

Mary Papenfuss
The Huffington Post, May 11, 2018

The military is diverse, but you wouldn't know it from this White House event honoring service moms and spouses...

Twitter users have been poring over photos of a recent White House event honoring military spouses and moms, wondering why there appeared to be no male spouses and few people of color.

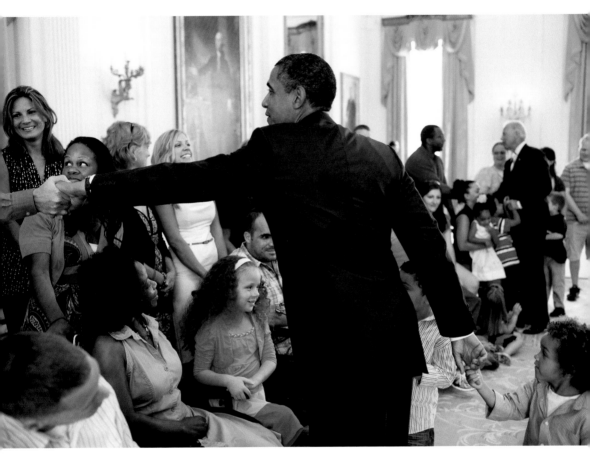

petesouza ✦ The President and Vice President greet military families in 2011.

May 11, 2018

Donald J. Trump ✔
@realDonaldTrump

The so-called leaks coming out of the White House are
a massive over exaggeration put out by the Fake News
Media in order to make us look as bad as possible.
With that being said, leakers are traitors and cowards,
and we will find out who they are!

May 14, 2018 3:46 PM

petesouza ✔ Pretty sure Bo never leaked in the Oval Office. Believe me! ▶

May 16, 2018

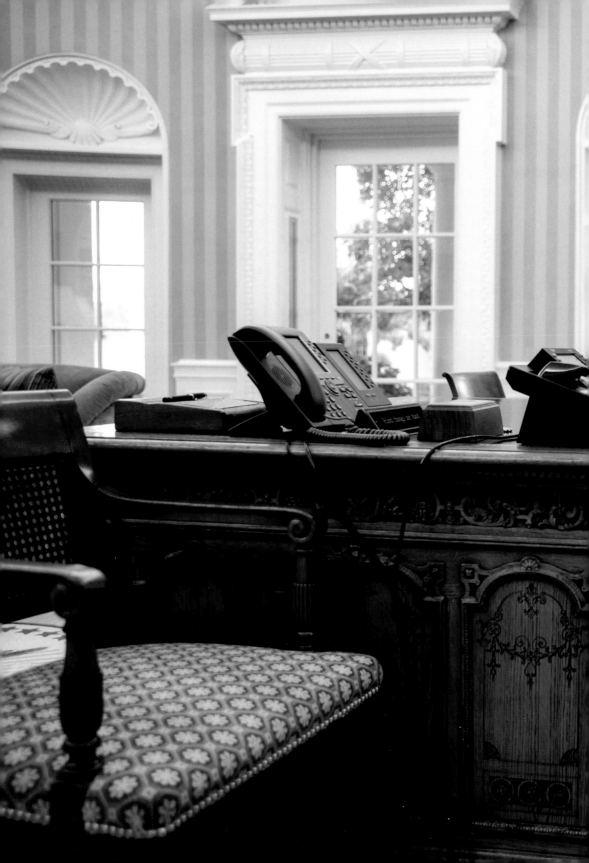

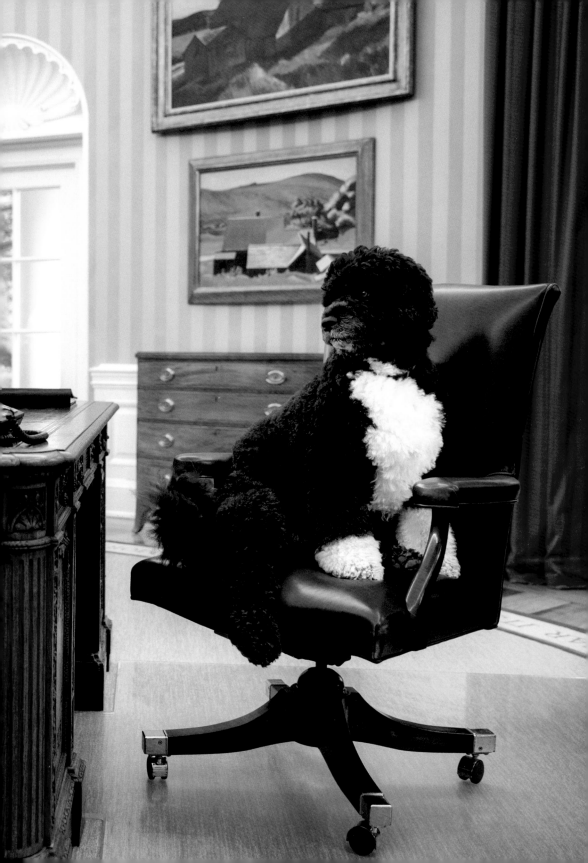

Donald J. Trump ✔
@realDonaldTrump

Sleepy Eyes Chuck Todd of Fake News NBC just stated that we have given up so much in our negotiations with North Korea, and they have given up nothing. Wow, we haven't given up anything & they have agreed to denuclearization (so great for World), site closure, & no more testing!

April 22, 2018 7:50 AM

Donald J. Trump ✔
@realDonaldTrump

Headline: "Kim Prepared to Cede Nuclear Weapons if U.S. Pledges Not to Invade" - from the Failing New York Times. Also, will shut down Nuclear Test Site in May.

April 29, 2018 9:59 PM

Donald J. Trump ✔
@realDonaldTrump

Very good news to receive the warm and productive statement from North Korea. We will soon see where it will lead, hopefully to long and enduring prosperity and peace. Only time (and talent) will tell!

May 25, 2018 7:14 AM

petesouza ✔ Looking out from inside the Blue House in Seoul, Republic of Korea.

May 16, 2018

Donald J. Trump ✔
@realDonaldTrump

Can you imagine the anger and disgust when the heads of other countries found out that their cell phones were being tapped by NSA.Obama mess

October 26, 2013 8:05 AM

Donald Trump Reportedly Ignores Cellphone Security Measures Because He Thinks They're Inconvenient

Vox, May 22, 2018

According to a new report from Politico, Trump has bucked cellphone security protocols as president because they're too annoying to deal with.

petesouza ✔ Michelle Obama snatches an iPhone away from her husband.

May 23, 2018

Donald J. Trump ✓
@realDonaldTrump

WITCH HUNT!

May 23, 2018 8:34 AM

Donald J. Trump ✓
@realDonaldTrump

Clapper has now admitted that there was Spying in my campaign. Large dollars were paid to the Spy, far beyond normal. Starting to look like one of the biggest political scandals in U.S. history. SPYGATE - a terrible thing!

May 24, 2018 7:21 AM

Donald J. Trump ✓
@realDonaldTrump

This whole Russia Probe is Rigged. Just an excuse as to why the Dems and Crooked Hillary lost the Election and States that haven't been lost in decades. 13 Angry Democrats, and all Dems if you include the people who worked for Obama for 8 years. #SPYGATE & CONFLICTS OF INTEREST!

May 26, 2018 2:41 PM

petesouza ✔ Learning how to spy with help from aide Katie Johnson.

May 24, 2018

NFL Owners Say Players Must Stand for the National Anthem

CNN, May 24, 2018

Trump: NFL Players Who Don't Stand During National Anthem Maybe "Shouldn't Be in the Country"

CNN, May 25, 2018

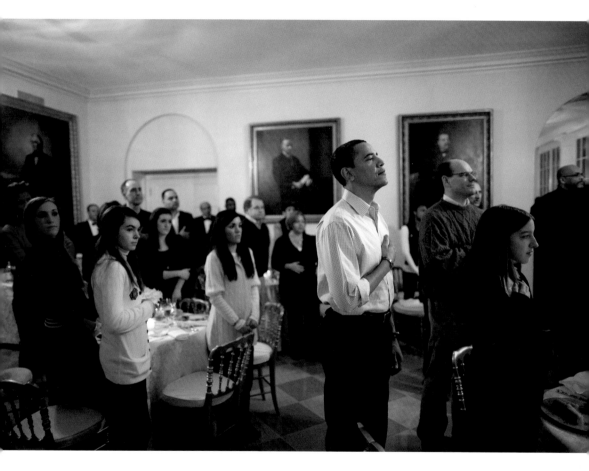

petesouza ✔ President Obama and his guests stand during the National Anthem before watching the Super Bowl on TV in 2009. I'm still waiting to see a similar picture from last year at Mar-a-Lago. And if the current President and his guests were not standing during the National Anthem, do we kick them all out of the country?

May 25, 2018

Donald J. Trump ✓
@realDonaldTrump

Happy Memorial Day! Those who died for our great country would be very happy and proud at how well our country is doing today. Best economy in decades, lowest unemployment numbers for Blacks and Hispanics EVER (& women in 18years), rebuilding our Military and so much more. Nice!

May 28, 2018 7:58 AM

Trump Slammed for Boasting About Presidency in Memorial Day Tweet

ABC News, May 28, 2018

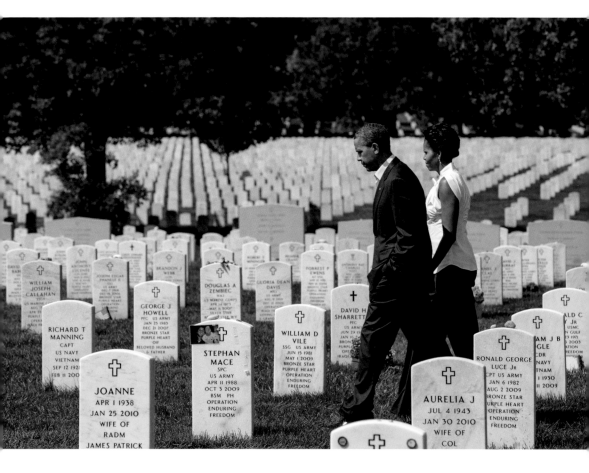

petesouza ✔ Arlington National Cemetery, 2011. Remembering those who sacrificed for all of us.

May 28, 2018

Donald J. Trump ✓
@realDonaldTrump

"This investigation involved far more surveillance than we ever had any idea about. It wasn't just a wiretap against a campaign aide...it was secretly gathering information on the Trump Campaign...people call that Spying...this is unprecedented and scandalous." Mollie Hemingway

May 29, 2018 5:49 AM

Donald J. Trump ✓
@realDonaldTrump

The 13 Angry Democrats (plus people who worked 8 years for Obama) working on the rigged Russia Witch Hunt, will be MEDDLING with the mid-term elections, especially now that Republicans (stay tough!) are taking the lead in Polls. There was no Collusion, except by the Democrats!

May 29, 2018 6:00 AM

Donald J. Trump ✓
@realDonaldTrump

Why aren't the 13 Angry and heavily conflicted Democrats investigating the totally Crooked Campaign of totally Crooked Hillary Clinton. It's a Rigged Witch Hunt, that's why! Ask them if they enjoyed her after election celebration!

May 29, 2018 6:09 AM

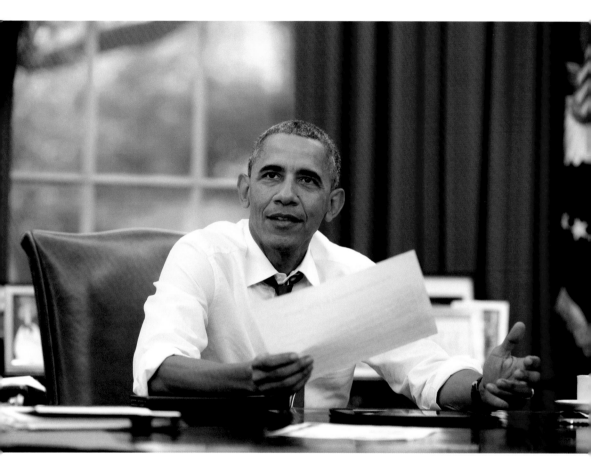

petesouza ✔ Back when the President of the United States worked at his desk, and didn't tweet every hour about nonsensical half-truths and straight-out lies.

May 29, 2018

"Roseanne" Canceled After Roseanne Barr's Racist Tweet About Valerie Jarrett

AOL News, May 29, 2018

Donald J. Trump ✓
@realDonaldTrump

Bob Iger of ABC called Valerie Jarrett to let her know that "ABC does not tolerate comments like those" made by Roseanne Barr. Gee, he never called President Donald J. Trump to apologize for the HORRIBLE statements made and said about me on ABC. Maybe I just didn't get the call?

May 30, 2018 10:31 AM

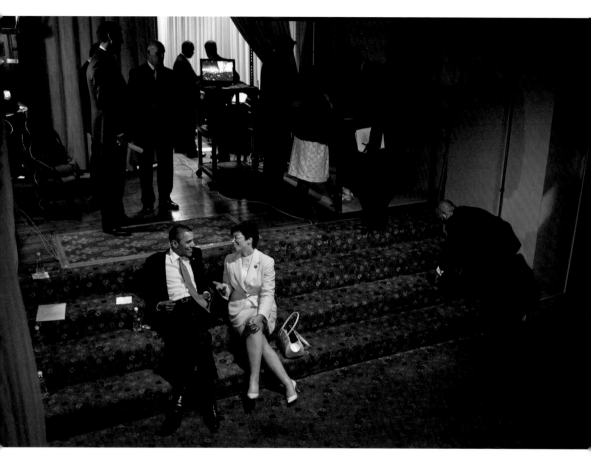

petesouza ✓ Hi, VJ. Bye, Roseanne.

May 29, 2018

Trump Tweetstorm Continues from Camp David

Deadline, June 3, 2018 (Day 500 of the Trump administration)

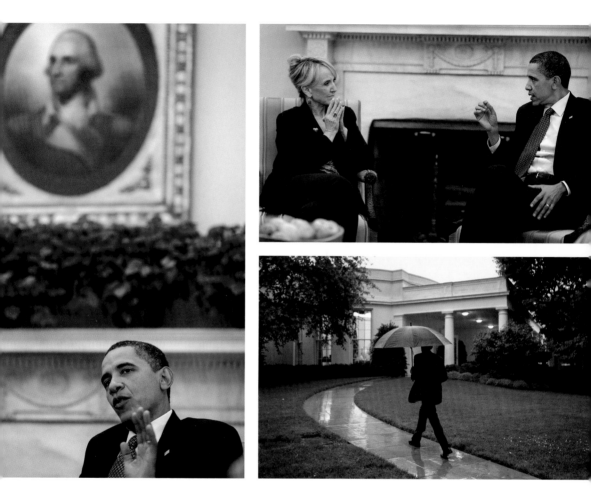

petesouza ✔ Day 500 of the Obama administration. A busy, though not necessarily visually exciting day for President Obama: He attended a presentation by Sasha at her school; met with advisors about the BP oil spill; met with Arizona Governor Jan Brewer on immigration; participated in an interview with Larry King; met with senior advisors; greeted National Spelling Bee winner Kavya Shivashankar; traveled to the State Department to attend a U.S.-India strategic dialogue reception. He did not send out a flurry of tweets.

June 3, 2018

Donald J. Trump ✓
@realDonaldTrump

PM Justin Trudeau of Canada acted so meek and mild during our @G7 meetings only to give a news conference after I left saying that, "US Tariffs were kind of insulting" and he "will not be pushed around." Very dishonest & weak. Our Tariffs are in response to his of 270% on dairy!

June 9, 2018 7:04 PM

petesouza ✔ Bros. (Sorry, Joe Biden.)

June 10, 2017

Robert De Niro Bleeped at Tony Awards for Trump F-Bomb

Associated Press, June 11, 2018

NEW YORK—With a bleep on live television and double fists raised in the air, Robert De Niro got the theater crowd on its feet at the Tony Awards with a rousing political introduction of his old friend Bruce Springsteen that was focused squarely elsewhere: on President Donald Trump...

De Niro said of Springsteen: "Bruce, you can rock the house like nobody else and even more importantly in these perilous times, you rock the vote, always fighting for, in your own words, truth, transparency and integrity in government. Boy, do we need that now."

petesouza ✔ Both were remarkable, in their own unique ways, at the Tony Awards.

June 11, 2018

Trump Returns Salute of North Korean General at Summit, State Media Footage Reveals

CNN, June 14, 2018

petesouza ✺ She knew who to salute and who not to salute.

June 14, 2018

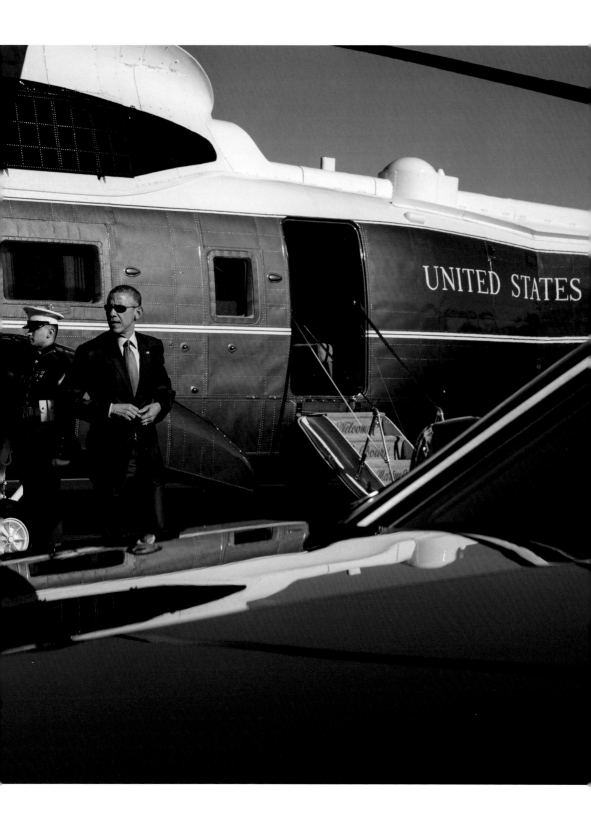

What Comes Next?

Throwing shade is one thing, but it's time
for us to take the next step.

It's not enough to voice disbelief at what's taking place.
Let's use our energy to do something about it.

Vote, for one.
Help others get to the polls.
March in the streets for issues that are important to you.
Write or call your Congressperson about how you feel.
It all matters.

It may take a while.
But let's bring respect back to the Oval Office.
Let's bring respect back to our country.

As Abraham Lincoln said at Gettysburg, our task is that

"government of the people,
by the people,
for the people,
shall not perish from the earth."

Acknowledgments

Thank you to all my Instagram followers for your continued
support. I couldn't have done this without you.

Thanks to everyone who knowingly, and unknowingly,
contributed to this book.

Many journalists—especially at *The New York Times,*
The Washington Post, and *The New Yorker*—deserve special praise
for their incredible work during the current presidency.

But most of all, thank you to all of you who have mobilized
to let your voices be heard. A special thanks to the
kids from Parkland—none of whom I've ever met—for standing up
and speaking out. You have inspired me, and millions of others.

As always, thanks to Patti, Alexander, and Callie.

Little, Brown and Company
Hachette Book Group
1290 Avenue of the Americas, New York, NY 10104
littlebrown.com

First Edition: October 2018

Little, Brown and Company is a division of Hachette Book Group, Inc.
The Little, Brown name and logo are trademarks of Hachette Book Group, Inc.

The publisher is not responsible for websites (or their content)
that are not owned by the publisher.

The Hachette Speakers Bureau provides a wide range of authors for speaking events.
To find out more, go to hachettespeakersbureau.com or call (866) 376-6591.

The author is grateful for permission to reprint lines from "This Land Is Your Land,"
Words and Music by Woody Guthrie WGP/TRO-© Copyright 1956, 1958, 1970 and 1972
(copyrights renewed) Woody Guthrie Publications, Inc. & Ludlow Music, Inc., New York, NY,
administered by Ludlow Music, Inc. International Copyright Secured. Made in U.S.A. All Rights
Reserved Including Public Performance For Profit. Used by Permission.

ISBN 978-0-316-42182-9 (hardcover) / 978-0-316-49037-5 (signed edition)
LCCN 2018946890

10 9 8 7 6 5 4 3 2 1

Printed in the United States of America by Meridian Printing

BOOK DESIGN BY YOLANDA CUOMO DESIGN

Associate Designer: Bonnie Briant
Junior Designer: Bobbie Richardson

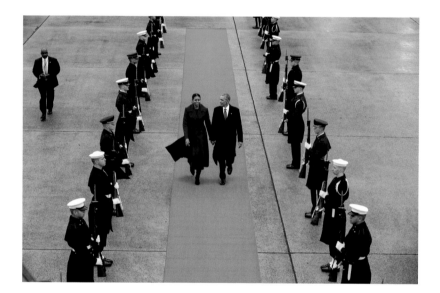